The Williams
Collection
of East Asian
Ceramics

The Detroit
Institute of Arts

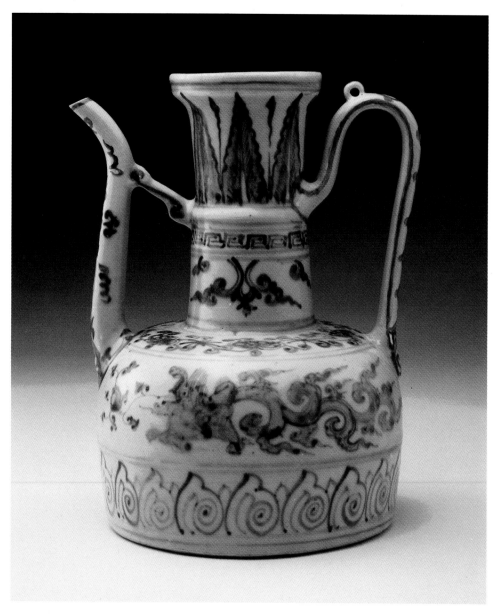

138. *Ewer*

The Williams Collection of East Asian Ceramics

The Detroit Institute of Arts, 1985

Text and Introduction by Kamer Aga-Oglu

©1985 The Detroit Institute of Arts
ISBN 0-89558-109-4

Cover: No. 171

Frontispiece: No. 138

Contents

Preface and Acknowledgments

Justice and Mrs. G. Mennen Williams generously presented a major portion of their fine collection of Asian ceramics to the Detroit Institute of Arts in 1972. *The Williams Collection of East Asian Ceramics at the Detroit Institute of Arts* is a comprehensive scholarly catalogue documenting the Williamses' gift, and it will provide a useful and beautiful publication on this interesting and unique collection of ceramic pieces from a variety of Asian cultures. We are very grateful to Justice and Mrs. Williams for their continuing interest in the museum and support for its projects.

This informative catalogue was written in 1978 by Kamer Aga-Oglu. In the time intervening since the completion of the manuscript, several publications have appeared with information based upon more recent research. Unfortunately, there has been no opportunity for this catalogue to be substantially updated. The past year has been marked by frail health for the author who, to our sorrow, died on August 14, 1984, shortly before this publication went to print.

The realization of *The Williams Collection of East Asian Ceramics* brings us great pride. We wish to acknowledge the invaluable assistance on this project of several members of the staff: Suzanne W. Mitchell, Curator, Sandra Collins, Associate Curator, and Margaret A. Stensland, Coordinator, Department of Asian Art; Julia Henshaw, Director of Publications, Cynthia Newman Helms, Associate Director of Publications, and Cynthia Jo Fogliatti, Editorial Assistant; and Dirk Bakker, Director of Photography, and Robert H. Hensleigh, Associate Director of Photography. Our gratitude is also extended to Andrea P.A. Belloli of Borax Books for her initial editing of the catalogue and to Thomas Kramer for his aid in the photography of the collection.

Michael Kan
Acting Director
and
Curator of African, Oceanic, and New World Cultures

About the Author

Kamer Aga-Oglu received a degree in Oriental Art History from the University of Michigan in 1938. Later the same year, she began as Research Assistant in the university's museums of archaeology and anthropology. In addition to her duties for the Museum of Anthropology, she began lecturing and teaching for the Department of Anthropology in 1949. By 1956 she had risen to the position of Curator of the Division of the Orient in the Museum of Anthropology. Mrs. Aga-Oglu continued to serve as curator and to teach in the Department of Anthropology and in 1962 became an Associate Professor in the Department of the History of Art. In 1972 she was promoted to Professor. She retired from the University of Michigan in 1973 and was made Curator and Professor Emeritus in 1974.

Throughout her long history with the university, Kamer Aga-Oglu was frequently in contact with the Detroit Institute of Arts. Her husband, Dr. Mehmet Aga-Oglu, was Curator of Near Eastern Art at the Art Institute from 1929 to 1936 and Honorary Curator of Near Eastern Art in 1937 and 1938. The Aga-Oglus' association with the Art Institute was to benefit the museum in a variety of ways for many years. Mrs. Aga-Oglu was a scholar whose energy and enthusiasm contributed greatly to her field and endeared her to those who were fortunate enough to work with her.

China: Modern Provinces

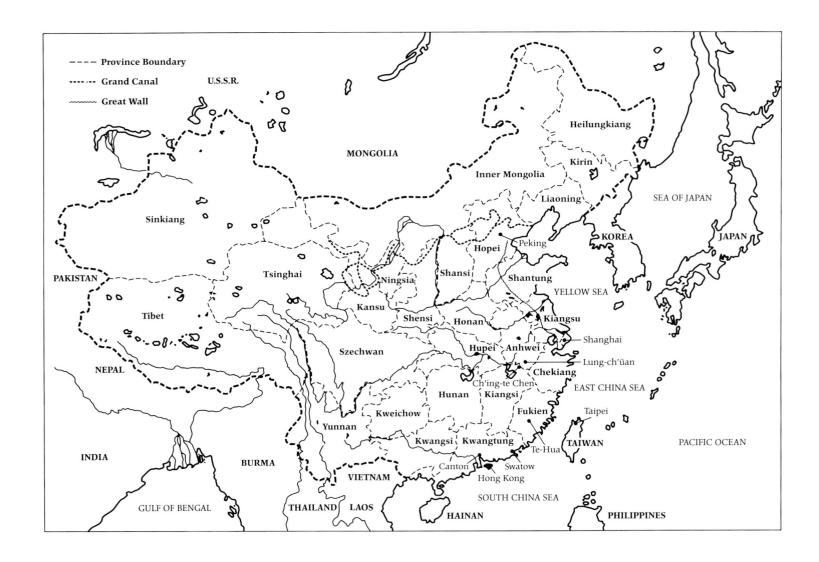

Southeast Asia in 1970

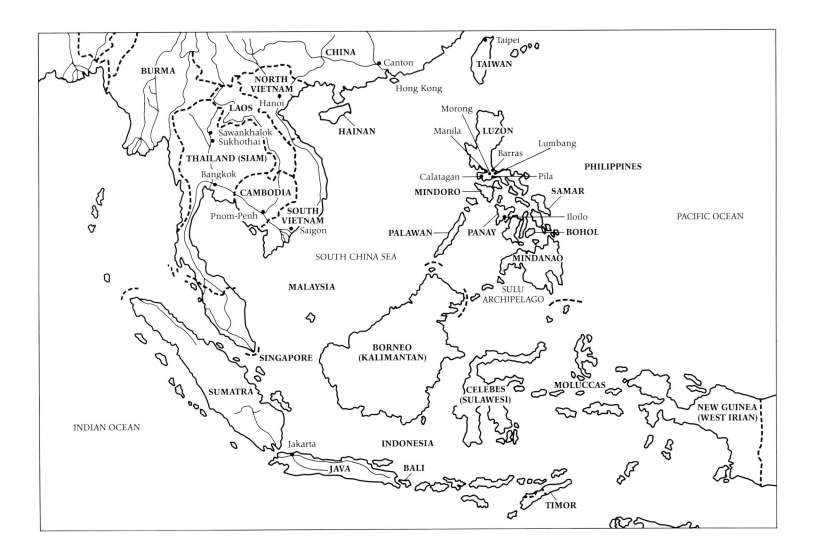

The impressive collection of Chinese, Vietnamese, Thai, and Philippine ceramic wares described in this catalogue was donated to the Detroit Institute of Arts by Justice and Mrs. G. Mennen Williams in 1972. It is one section of a larger collection of East Asian ceramics, other portions of which have been donated by the Williamses to the Flint Institute of Arts and the University of Michigan Museum of Anthropology.[1] A final section of ceramics has been retained in the Williamses' private collection.[2]

The entire collection was brought together by Mrs. Williams in 1968-69, when her husband was United States Ambassador to the Philippines. During their residence in Manila, Mrs. Williams became interested in the Chinese and other Asiatic wares that had been recovered from ancient burial and dwelling sites in the Philippines and which were being traded in Manila. In addition to these wares, a small number of Chinese, Vietnamese, and Thai ceramics were obtained in Bangkok, Singapore, and Taipei. Both her collecting and her decision to donate parts of the collection to museums in Michigan were inspired by her recognition of the historical significance of these wares. Guided by her keen perception and good judgment, Mrs. Williams was able to bring together in a short period of time a remarkable selection of representative types of Asiatic pottery.

It should be noted that the ceramic wares obtained in Manila, which form the bulk of the entire collection, were found by private citizens, and thus the exact locations at which most of the pieces were found are not known. However, informa-tion regarding a small number of wares that have been attributed to specific areas is reflected in the catalogue.

The Williamses' generous gift has broadened the scope of the museum's original holdings of East Asian ceramics by adding many new types of wares. This makes the collection a valuable asset for students and specialists in the field and a source of inspiration for the general public.

Chinese Wares
The Chinese pottery that forms the main body of the Williams Collection consists chiefly of celadon and blue-and-white wares. The remaining portion consists of small groups of wares, the most notable being *ch'ing-pai* ware. As a rule, this ware has a pure white porcelain body that is either plain or decorated with incised or molded designs and covered with a transparent glaze of a pale bluish tinge; hence its Chinese names, *ch'ing-pai,* meaning "bluish white," or *ying-ch'ing,* meaning "shadow blue." One of the finest porcelain wares developed during the Sung Dynasty (960-1279), *ch'ing-pai* continued to be produced throughout the Yüan period (1280-1368). *Ch'ing-pai* vessels are found in a wide variety of shapes and display various modes of decoration (see nos. 71-85, 88, 117). They range in quality from those with thinly potted, translucent bodies and pale, blue-tinged transparent glazes to coarser types in which the glaze is often of a grayish tone.

The center of *ch'ing-pai* production was Ch'ing-te Chen in Kiangsi province, although the kilns of other southern provinces, particularly Fukien, made similar wares. *Ch'ing-pai* was made in large quantities for markets in China and for export, particularly to the islands of Southeast Asia, as is evidenced by the amount of it found in the Philippines alone.

Celadon ware was perfected during the Sung period (960-1279), although its production continued in the Yüan (1280-1368) and Ming (1368-1684) periods. The center of manufacture was the district of Lung-ch'üan and other areas in Chekiang province.[3] Because of its popularity, the ware was also produced in other southern provinces such as Fukien and Kuangtung. Made for trade at home as well as for export, celadon is a utilitarian ware, consisting mainly of dishes, bowls, saucers, small jars, and pouring vessels. The body of the ware ranges from a grayish white porcelaneous stoneware to a white porcelain of rather fine grain. The thick feldspathic glaze ranges in color from grass green or sea green to olive green and is often crackled.

Like *ch'ing-pai,* this ware takes its name from the glaze, which contains iron oxide that when fired in a reducing atmosphere results in the much-desired grass or sea green color.[4] The vessels are either plain or have an incised, carved, or stamped underglaze decoration of floral motifs, wave designs, or lotus petals. Some pieces display dragons or fish molded in high relief. Because of its durability, simple practical forms, and pleasing jadelike glaze, celadon enjoyed great popularity and was exported in

large quantities to various countries of East and Southeast Asia as well as the Near East, an area extending from Japan and the Philippines to Egypt.

The celadon ware in the Williams Collection (nos. 13-70) ranges in date from the Sung to the Ming period and consists chiefly of dishes, bowls, small jars, and some vessels of other shapes, among which a bell with a leopard-shaped handle and a vase with cover are outstanding (nos. 13 and 14). Also notable are a cup with fish-shaped handles and a tea pot with cover in the form of a pumpkin (nos. 15 and 45). A group of dishes, each decorated with a pair of molded fish (nos. 24-33), and a large dish with a dragon pursuing a pearl (no. 59) are of particular importance since they show the technique of decoration in molded relief, first developed in the late Sung period (1127-1279), but more widely used in the following Yüan era.

Of particular interest is a large celadon dish (no. 61), which in shape, the quality of its porcelain body, and the thick, sea green glaze is typical of the Ming celadon made in the kilns of Chekiang. What sets this dish apart from the general celadon type is the delicate white slip decoration on the inside center. This decoration is of the same type seen in some of the so-called Swatow wares, which have a coarse porcelain body and a thin, glossy glaze of brown, greenish white, or blue (see no. 62). The presence of a white slip decoration on this celadon dish prompts the assumption that some of the true celadon ware made in Chekiang was decorated in the style of the Swatow wares, which were manufactured in the bordering province of Fukien.[5] The sand accretions on another dish (see no. 61), a feature seen in most of the mass-produced Swatow porcelains, could occur in any ware due to accident, faulty firing conditions, or careless handling of the vessels after firing.

The Williams Collection also includes a group of spotted *ch'ing-pai* and early blue-and-white wares, consisting of double-gourd-shaped ewers and small jars, that are of particular interest. These pieces show the new techniques of decoration that were developed during the Yüan period, namely the use of iron oxide to produce brown spots in the glaze (see nos. 118-123) and the painting of porcelain with designs in cobalt blue under a transparent glaze (see nos. 124-132). This technique of painting in cobalt blue on a white body led to the development of the familiar blue-and-white porcelain of China. This ware, in which a pictorial style of decoration first evolved, has continued to be highly popular. (The pictorial approach was later carred on in overglaze enamel decorations as well.)

The blue-and-white ware of the Ming Dynasty is represented by vessels of various shapes and with varying decoration (see nos. 133-168, 171-173). Outstanding among them is a large ewer (no. 138) decorated with two fantastic dragon-like creatures with sprawling tails which are of the same type that is seen in a number of blue-and-white pieces assigned to various dates ranging from the early fifteenth to the early sixteenth century. Also noteworthy is a finely potted bowl (no. 153) decorated in the center with a bunch of lotus and water weeds tied with a band. This style of floral composition is seen in the centers of numerous blue-and-white dishes and bowls of the early fifteenth century. Of particular interest are two dishes (nos. 157 and 158) decorated at the center with a landscape containing human figures which rarely appear in the decoration of blue-and-white porcelain made for export.

Like its predecessor, celadon, the blue-and-white porcelain of China became a popular medieval trade item throughout the Orient, eventually finding its way to Europe and America. The source of its popularity was no doubt its pure white porcelain body, unknown outside China, and its pleasing blue decoration of naturalistic floral and plant designs—landscapes with trees, rocks, ponds, birds, and animals. The center of blue-and-white production was the great pottery town of Ch'ing-te Chen, the location of the special kilns that made the blue-and-white and other wares for the Ming and Ch'ing (1644-1912) imperial households. However, in addition to the kilns in Kiangsi, blue-and-white ware was made in other provinces, particularly Fukien, which produced many of the wares for the markets of Southeast Asia.

The blue-and-white and celadon wares of China were in great demand by foreign markets and were exported to Japan, various parts of Southeast Asia (especially the Philippines), and to the countries of the Near East, where they were greatly cherished by heads of state and where they have been preserved in large numbers in the Imperial Ottoman Collection of the Topkapu Sarayi Müzesi in Istanbul[6] and in the Ardebil Collection housed in the Archaeological Museum in Teheran.[7]

Vietnamese Wares

The wares of Vietnam (formerly Annam) are represented in this collection by a number of blue-and-white porcelain vessels (nos. 195-205). Notable among them are a pear-shaped bottle decorated with floral medallions set on a ground of waves, with borders of stiff leaves and lotus panels (no. 195), and a tea pot decorated with peony scrolls (no. 197). In shape and decoration both of these pieces show a close affinity to early Ming blue-and-white ware, which influenced the development of Vietnamese blue-and-white porcelain. The classification and dating of this ware is problematic because of the lack of historical and archaeological data. Therefore, the dating of Vietnamese vessels to the fifteenth or six-teenth century is based chiefly on their relationships in shape and decoration to their Ming prototypes and on the similarity of the style of their decoration to that of the well-known Vietnamese blue-and-white bottle in the Topkapu Sarayi Müzesi, which carries a date mark corresponding to A.D. 1450.[8]

The blue-and-white porcelain and other wares of Vietnam were as popular among the peoples of the Indonesian and Philippine archipelagos as the wares of China and Thailand and were exported to those islands in considerable amounts.[9]

Thai Wares

The ceramics of Thailand (formerly Siam) included here consist of small groups of Sawankhalok wares (nos. 206-223), notable among which are the celadon and wares decorated with painted or incised underglaze designs. Prominent among these are a celadon stem bowl and dish (nos. 206 and 207), a box with incised designs (no. 212), and a *Kendi* vessel with white slip decoration (no. 217). Thai celadon, which was the major product of the Sawankhalok kilns, was developed under the influence of the famous celadon ware of China. This relationship is evident in the glaze, the shape, and the underglaze incised decoration of many of its pieces, as exemplified by the stem bowl and large dish (nos. 206 and 207). The celadon and other ceramics of Sawankhalok, as well as the wares of the neighboring kiln center of Sukhothai, were important Thai export goods destined for the demanding markets of Indonesia and the Philippines. They were made in large quantities during the fourteenth and fifteenth centuries—the most active period of production of those kilns.[10]

Philippine Pottery

In addition to East Asian ceramic wares, the Williams Collection contains six pieces of native Philippine earthenware (nos. 224-229). They have a reddish buff body, some being decorated with incised triangles or crosshatched patterns, and consist of pouring vessels, cooking pots, and a vase. Significant among these is a pouring vessel with two spouts (no. 224). This ware represents one of the early types of native Philippine pottery found in burial and dwelling sites of the Prehistoric period, dating from the first to the tenth century.

Kamer Aga-Oglu
Curator Emeritus
Division of the Orient
The Museum of Anthropology
and
Professor Emeritus
History of Art
The University of Michigan

Notes

1. See Aga-Oglu 1972.
2. See Aga-Oglu 1975.
3. See Palmgren/Steger/Sundius 1963.
4. The designation celadon, which originated in Europe, probably derived from Celadon, the name of the major character in a popular seventeenth-century French play whose gray green robe resembled the color of this Chinese ware, which was then being imported to Europe. In China the ware is called *ch'ing tz'u,* meaning "green porcelain."
5. For more information on Swatow ware, see Aga-Oglu 1955.
6. See Zimmermann 1930 and Pope 1952.
7. Bahrami 1949-50 and Pope 1956.
8. Hobson 1933-34, p. 13, pl. 4.
9. Spinks 1965, pp. 93 and 95.
10. *Ibid.,* pp. 89-95, 112-113.

Author's Acknowledgments

The preliminary preparations for this catalogue were made at the Detroit Institute of Arts, where I was given every possible assistance by Susan F. Rossen, formerly Coordinator of Publications at the Art Institute and now Editor and Coordinator of Publications at the Art Institute of Chicago, to whom I acknowledge my debt. My thanks also go to Michael Gilmartin, former Curatorial Assistant in the Department of Ancient Art at the Detroit Institute of Arts, who made the study photographs and helped me in the preparation of preliminary notes for the catalogue captions. I am much indebted to Weiying Wan, Head of the Asia Library of the University of Michigan, for the translation of the Chinese inscriptions (nos. 80, 149, 167, and 168). Finally, I am most grateful to Dr. Frederick J. Cummings, former Director of the Detroit Institute of Arts, for his interest in this project and for the facilities provided for my work through his good office.

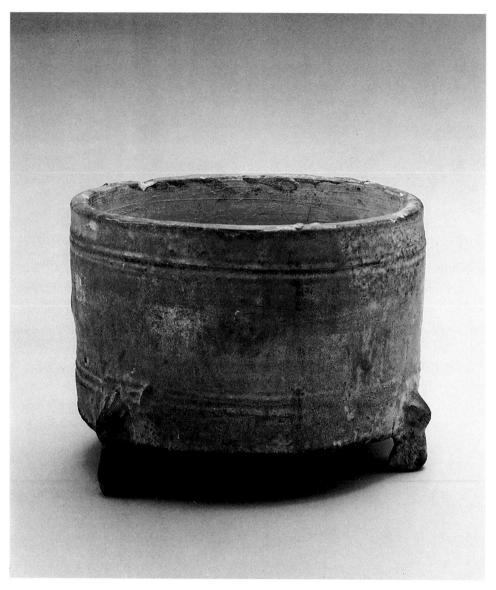

1. *Incense Burner*

1.
Incense Burner
China, Han Dynasty
Lead-glazed earthenware
H. 16.3 cm (6 3/8 in.)
73.305

This cylindrical incense burner with three feet has two horizontal grooves below the rim and two above the base. The earthenware body is covered with a thin, mottled, green lead glaze, except for the inside and base, which show a buff paste.

2.
Jar
China, Han Dynasty or later
Lead-glazed earthenware
H. 11.8 cm (4 5/8 in.)
73.306

The buff earthenware body of this jar is covered with a thin, brownish green, streaked lead glaze. It has a rounded shoulder, a wide mouth-rim, and a flat, unglazed base burned reddish brown.

Not illustrated.

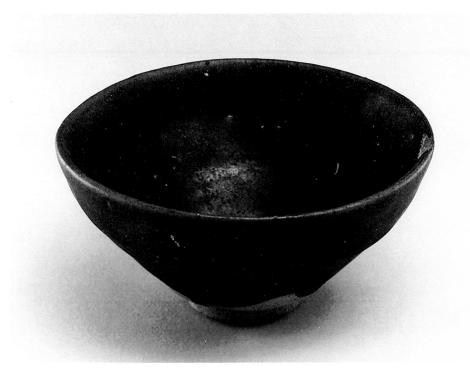

3. *Tea Bowl*

3.
Tea Bowl
China (Fukien Province), Sung Dynasty
Chien ware
Diam. 12.4 cm (4 7/8 in.)
72.662

This heavily potted bowl has a conical shape with a straight rim and a low, narrow foot-rim. The brown speckled glaze covering the dark gray stoneware body stops unevenly on the exterior above the foot.

Chien ware was produced during the Sung period in the kilns of Fukien province. These simple, sturdy bowls were used by the Chinese monks of the Ch'an Buddhist sect in their ceremonial tea drinking. Chien bowls were first brought to Japan by Japanese monks who had studied in Ch'an Buddhist monasteries. In Japan such bowls were prized by devotees of the tea ceremony and were called "Temmoku."

4.
Tea Bowl
China (Fukien Province), Sung Dynasty
Chien ware
Diam. 9.5 cm (3 7/8 in.)
72.661

This tea bowl is of the same type as no. 3.

Not illustrated.

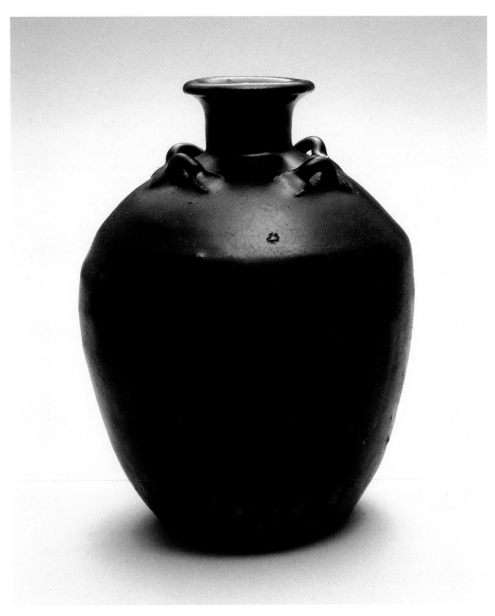

5. *Jar*

5.
Jar
China, Yüan Dynasty
Brown-glazed stoneware
H. 21 cm (8 1/4 in.)
73.326

This jar has an ovoid shape with a sloping shoulder, a narrow neck with flaring mouth-rim, and a concave base. On the shoulder are four loop handles. The gray stoneware body is covered with a thick, dark brown glaze, except for the base.

6.
Ewer
China, Yüan-early Ming Dynasty
Brown-glazed stoneware
H. 8.5 cm (3 3/8 in.)
72.584

This ewer has rounded sides, a narrow neck with flaring rim, a short spout, and a handle connecting the shoulder and rim. On the shoulder are two loops. The light gray stoneware body is covered with a brown glaze which stops unevenly above the concave platform base. The unglazed paste is of a light gray color.

Not illustrated.

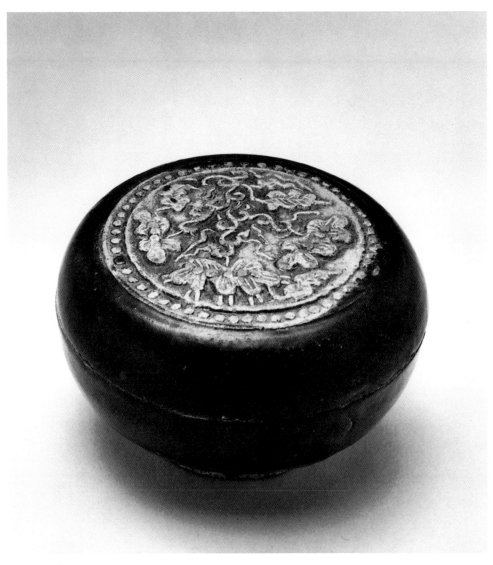

7.
Jar
China, late Sung Dynasty
Brown-glazed stoneware
H. 8.2 cm (3 1/4 in.)
72.647

This globular jar has a short, narrow neck flaring at the rim and a low foot-rim. The gray stoneware body is covered with a brown glaze, except for the foot-rim and base, which show a gray paste.

Not illustrated.

8.
Box with Cover
China, Yüan Dynasty
Brown-glazed stoneware
H. (with cover) 6.3 cm (2 1/2 in.)
73.336

This globular box has a flattened cover and a low platform base. A dark brown glaze covers the box inside and out, except for the lower sides and the base which show a buff paste. The cover has a dark brown glaze on the sides; its unglazed top is decorated with a molded floral spray and beaded ring and is coated with a transparent glaze. (For related boxes, see Locsin 1967, pl. 152; and Cheng 1972, pl. 5, no. 17.)

8. *Box with Cover*

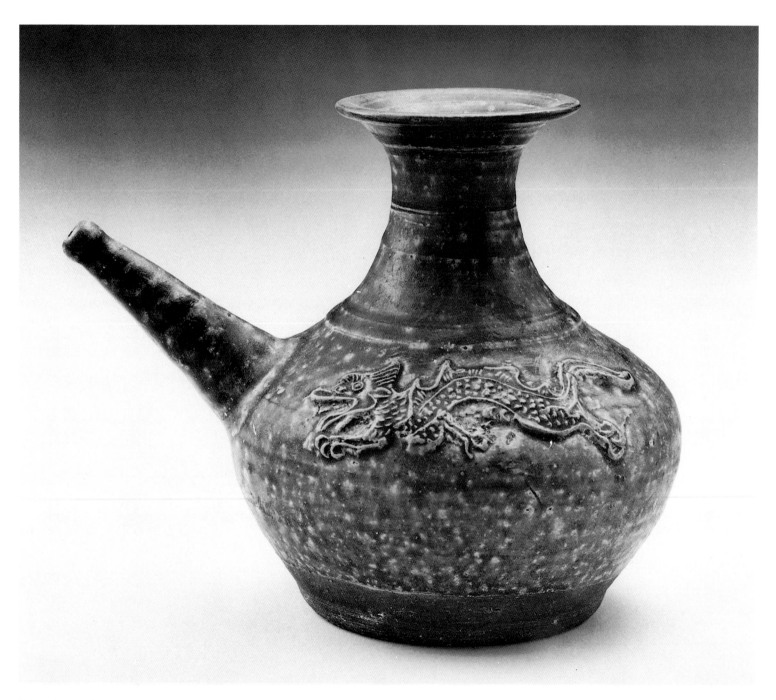

9. Kendi Vessel

9.
Kendi Vessel
China, Yüan Dynasty
Brown-glazed stoneware
H. 17.5 cm (6 7/8 in.)
Found in Lumbang, Laguna Province,
Philippines
72.673

This bulbous *kendi* drinking vessel has
a narrow neck flaring at the rim and a long,
slender spout. On the shoulder are two
dragons in molded relief. The gray stone-
ware body is covered with a thin, mottled
brown glaze which stops unevenly above
the base; the exposed body is washed
over with a brown slip. The slightly con-
cave base is unglazed. (For further
information on *kendi* drinking vessels,
see Sullivan 1957.)

10.
Jar
China, Ming Dynasty
Brown-glazed porcelain
H. 8.6 cm (3 3/8 in.)
Found on Samar Island, Philippines
72.676

This squat, globular jar has a broad
mouth and a concave base. The porcelain
body is covered with a glossy, grayish
brown, mottled glaze which stops unevenly
above the base.

Not illustrated.

11.
Jar
China, Ming Dynasty
Blue-glazed porcelain
H. 8.6 cm (3 3/8 in.)
Found on Samar Island, Philippines
72.677

In shape, body, and size, this jar is
similar to no. 10, except for its glossy,
grayish blue, streaked glaze.

Not illustrated.

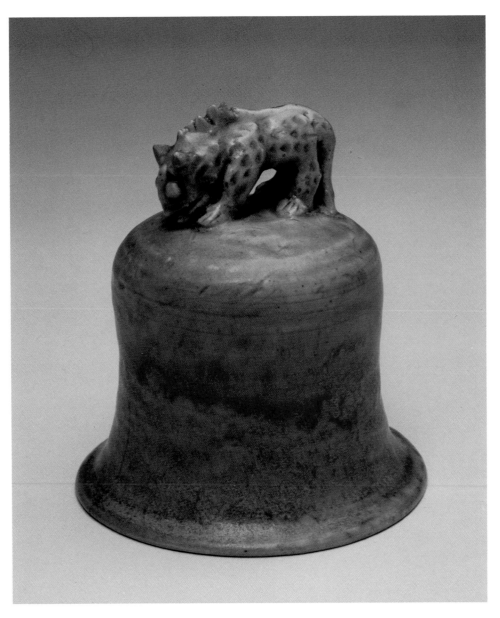

13. *Bell*

12.
Jar with Cover
China, Ming Dynasty
Cobalt blue-glazed porcelain
H. (with cover) 10.4 cm (4 1/8 in.)
72.697

This globular jar has a wide mouth,
a concave base, and a cover with a central
knob. The porcelain body is covered
with a dark blue glaze, except for the base
and inside of the cover.

Not illustrated.

13.
Bell
China, Yüan Dynasty
Lung-ch'üan celadon ware
H. 12.5 cm (4 15/16 in.)
72.688

This porcelain hand bell with a leopard-
shaped handle is covered with a sea green,
streaked glaze, except for the upper
portion of the interior.

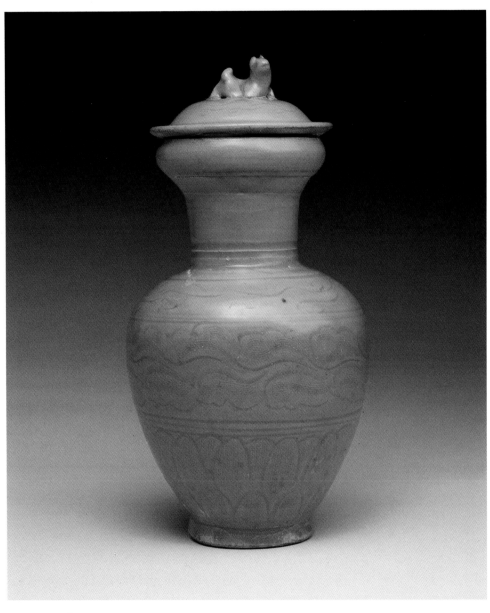

14.
Vase with Cover
China, Southern Sung Dynasty
Lung-ch'üan celadon ware
H. (with cover) 28.3 cm (11 1/8 in.)
73.358

This ovoid vase has a cup-shaped mouth, a short neck, a low foot-rim, and a flat, unglazed base. The incised decoration consists of a scroll border on the shoulder, a band of waves around the mid-section, and two rows of vertical petals above the foot. The domed cover with flaring edge is topped by a seated figure of a dog and is decorated with sketchy incised scrolls. The grayish white porcelain body is covered with a sea green glaze.

14. *Vase with Cover*

15. *Cup with Handles*

15.
Cup with Handles
China, Southern Sung Dynasty
Lung-ch'üan celadon ware
H. 7.5 cm (2 7/8 in.)
72.621

This cylindrical cup has a flaring rim, two stylized fish-shaped handles, and a sturdy foot-rim. The grayish white porcelain body is entirely covered with a grayish sea green glaze with fine crackle. (For similar cups, see Aga-Oglu 1975, no. 13.)

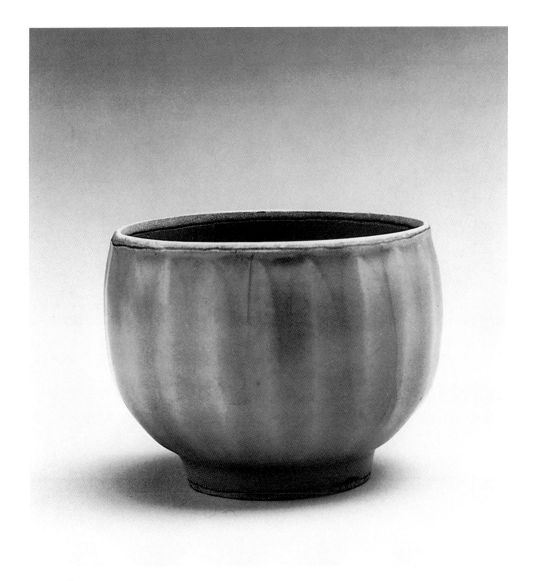

16. *Bowl*

16.
Bowl
China, Southern Sung Dynasty
Lung-ch'üan celadon ware
Diam. 9 cm (3 1/2 in.)
72.642

This cylindrical bowl has a wide mouth-rim, fluted sides, and a low foot-rim. Its porcelain body is covered with a grayish green glaze, except for the rim of the mouth. (For a similar bowl, see Aga-Oglu 1972, no. 52.)

17. *Bowl*

17.
Bowl
China, Southern Sung Dynasty
Lung-ch'üan celadon ware
Diam. 16.5 cm (6 1/2 in.)
72.619

This shallow bowl has slightly rounded
sides, a straight rim, and a narrow foot-rim
around a convex base. The grayish
white porcelain body is covered with an
olive green, crackled glaze, except for
the edge of the foot-rim. This bowl is a fine
example of Sung Lung-ch'üan celadon
ware.

18.
Bowl
China, Southern Sung Dynasty
Lung-ch'üan celadon ware
Diam. 16.8 cm (6 5/8 in.)
72.624

This deep bowl with rounded sides,
a straight rim, and a narrow foot-rim is dec-
orated on the outside with a carved petal
pattern. The grayish white porcelain body
is covered with an olive green glaze,
except for the base.

18. *Bowl*

19. *Bowl*

19.
Bowl
China, Southern Sung Dynasty
Lung-ch'üan celadon ware
Diam. 17.3 cm (7 in.)
72.641

This shallow bowl with rounded sides, a straight rim, and a narrow foot-rim is decorated on the outside with a carved petal pattern. The grayish white porcelain body is covered with an olive green glaze which is partially streaked on the inside.

20.
Dish
China, Southern Sung Dynasty
Lung-ch'üan celadon ware
Diam. 15 cm (5 7/8 in.)
72.660

This shallow dish with a straight rim and a low foot-rim is decorated on the outside with a carved petal pattern. The grayish white porcelain body is coated with a sea green glaze, except for the flat base.

Not illustrated.

21.
Bowl
China, late Sung Dynasty
Chekiang celadon ware
Diam. 16.8 cm (6 5/8 in.)
72.653

This bowl has rounded sides, a straight rim, and a low foot-rim. The grayish stoneware body is covered with an olive green glaze, except for the base and a ring on the inside bottom. The outside is decorated with a carved petal pattern.

Not illustrated.

22.
Bowl
China, late Sung Dynasty
Chekiang celadon ware
Diam. 17 cm (6 11/16 in.)
72.625

This bowl has rounded sides, a straight
rim, and a low foot-rim. The grayish white
stoneware body is coated with an olive
brown glaze, except for the foot, base, and
a ring on the inside bottom. The outside
is decorated with a carved petal pattern.

Not illustrated.

23.
Dish
China, late Sung Dynasty
Lung-ch'üan celadon ware
Diam. 12.8 cm (5 1/16 in.)
72.629

This dish with a fluted cavetto, a flat-
tened rim, and a low foot-rim has a porce-
lain body covered with a grayish sea
green glaze. (For a similar dish, see Aga-
Oglu 1972, no. 48 [bottom].)

Not illustrated.

24.
Dish
China, late Sung Dynasty
Lung-ch'üan celadon ware
Diam. 17.1 cm (6 3/4 in.)
72.665

This dish has a flattened rim and a low
foot-rim. It is decorated on the inside with
a centralized pair of fish applied in high
relief and a band of incised waves on the
cavetto. The porcelain body is covered
with a sea green glaze.

Not illustrated.

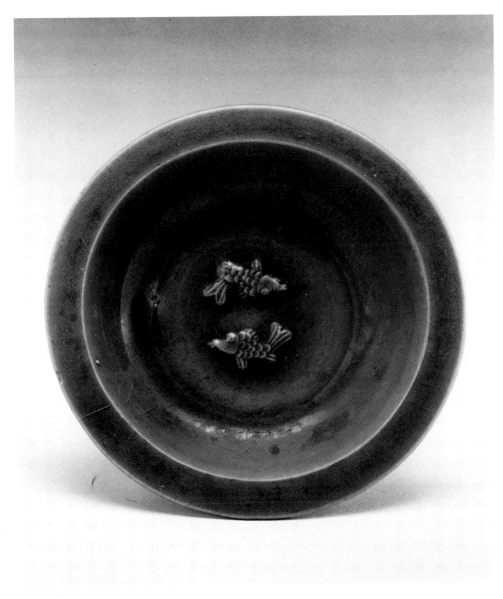

25.
Dish
China, late Sung Dynasty
Lung-ch'üan celadon ware
Diam. 12.7 cm (5 in.)
Found in Lumbang, Laguna Province,
Philippines
72.636

This dish with a flattened rim and a low foot-rim is decorated on the inside with a centralized pair of fish applied in high relief. The outside of the dish is patterned with a band of carved petals. The porcelain body has an olive green glaze. (For similar dishes, see Aga-Oglu 1972, no. 48 [top left]; Aga-Oglu 1975, nos. 20-22; and Cheng 1972, pl. 2, no. 5.)

25. *Dish*

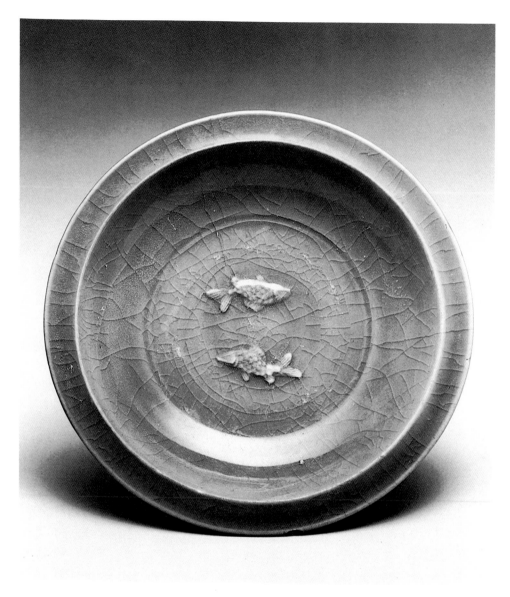

26.
Dish
China, late Sung Dynasty
Lung-ch'üan celadon ware
Diam. 20.9 cm (8 1/4 in.)
72.667

This dish has a flattened rim and a low foot-rim. It is decorated on the inside with a centralized pair of fish applied in high relief and on the outside with a band of carved petals. The porcelain body is covered with an olive green glaze.

27.
Dish
China, late Sung Dynasty
Lung-ch'üan celadon ware
Diam. 20.3 cm (8 in.)
72.668

This dish, with a pair of fish rendered in relief, is similar to no. 25.

Not illustrated.

26. *Dish*

28.
Dish
China, late Sung Dynasty
Lung-ch'üan celadon ware
Diam 11.7 cm (4 5/8 in.)
72.623

This dish, with a pair of fish rendered
in relief, is also similar to no. 25.

Not illustrated.

29.
Dish
China, late Sung Dynasty
Lung-ch'üan celadon ware
Diam. 20.6 cm (8 1/8 in.)
72.638

This dish, with a pair of fish rendered in
relief, is similar to no. 25, except that it has
a plain exterior.

Not illustrated.

30.
Dish
China, late Sung Dynasty
Lung-ch'üan celadon ware
Diam. 12.2 cm (5 in.)
72.640

This dish, with a pair of fish rendered
in relief, is similar to no. 25, except that it
is covered with a sea green glaze which
has turned olive green in parts.

Not illustrated.

31.
Dish
China, late Sung Dynasty
Lung-ch'üan celadon ware
Diam. 12.2 cm (5 in.)
Found in Lumbang, Laguna Province,
Philippines
72.663

This dish, with a pair of fish rendered in
relief, is also similar to no. 25, except that
it is covered in a sea green glaze.

Not illustrated.

32.
Dish
China, late Sung Dynasty
Lung-ch'üan celadon ware
Diam. 16.8 cm (6 5/8 in.)
Found in Lumbang, Laguna Province,
Philippines
72.626

This dish is also similar to no. 25,
except that it has a plain exterior and a
grayish green, crackled glaze.

Not illustrated.

33.
Dish
China, late Sung Dynasty
Lung-ch'üan celadon ware
Diam. 13.1 cm (5 3/16 in.)
72.622

This dish is of a coarse type with a flattened rim and a low, broad foot-rim. On the inside is a centralized pair of fish in indistinct low relief; on the outside is a band of incised petals. The grayish white porcelain body is covered with a pale sea green glaze, except for the base.

Not illustrated.

34.
Dish
China, late Sung-early Yüan Dynasty
Lung-ch'üan celadon ware
Diam. 16.1 cm (6 3/8 in.)
72.645

This dish with a flattened rim and a low foot-rim is decorated on the inside with a centralized stamped chrysanthemum spray and with incised waves on the cavetto. The porcelain body is covered with an olive green glaze, except for the base.

Not illustrated.

35.
Dish
China, early Ming Dynasty
Lung-ch'üan celadon ware
Diam. 21.9 cm (8 5/8 in.)
72.696

This shallow dish has a flattened, scalloped rim and a low foot-rim. It is decorated with a centralized stamped chrysanthemum spray and with sketchy incised scrolls on the cavetto and rim. The glossy, sea green glaze covering the porcelain body has turned brownish in parts. On the base are patchy washes of thin glaze.

Not illustrated.

36.
Dish
China, Ming Dynasty
Lung-ch'üan celadon ware
Diam. 21.6 cm (8 1/2 in.)
72.628

This shallow dish with a flattened, scalloped rim and a low foot-rim is decorated on the inside with sketchy incised wave motifs on the cavetto and rim. The porcelain body is covered with a grayish sea green glaze, except for the base.

Not illustrated.

37.
Dish
China, Ming Dynasty
Celadon ware
Diam. 26 cm (10 1/4 in.)
72.678

This shallow dish has a flattened, foliated rim, a low foot-rim, and a slightly fluted exterior. Inside on the cavetto is an indistinct incised floral design. Covering the porcelain body is a grayish sea green glaze with chalky white streaks. The base is unglazed.

Not illustrated.

38. *Dish*

38.
Dish
China, Yüan-early Ming Dynasty
Lung-ch'üan celadon ware
Diam. 10.4 cm (4 1/8 in.)
72.689

This deep dish with a slightly sunken base
has ribbed sides, girded on the outside
by a raised band, that simulate the sides of
a bamboo bucket. The porcelain body is
covered with a grayish green glaze, except
for a ring around the center of the base.
(For similar dishes, see Aga-Oglu 1972,
no. 56; and Aga-Oglu 1975, no. 29.)

39.
Dish
China, Ming Dynasty, 15th century
Lung-ch'üan celadon ware
Diam. 11.7 cm (4 5/8 in.)
72.664

This deep dish with a flaring rim and a
low foot-rim is decorated on the inside with
incised waves at the rim and a lotus in the
center. The porcelain body is covered with
a celadon glaze which oxidized in fir-
ing and turned reddish green. An unglazed
ring surrounds the center of the base.

Not illustrated.

40.
Dish
China, Ming Dynasty, 15th century
Lung-ch'üan celadon ware
Diam. 13.6 cm (5 7/8 in.)
73.339

This shallow dish has flaring sides,
a foliated rim, and a low foot-rim. It is dec-
orated inside with a sketchy incised
floral scroll. A bluish green glaze covers the
porcelain body, except for the base.
(For similar dishes, see Aga-Oglu 1972,
no. 57.)

Not illustrated.

41.
Dish
China, Ming Dynasty, 15th century
Lung-ch'üan celadon ware
Diam. 13.9 cm (5 1/2 in.)
Found in Oton, Iloilo, Panay Island,
Philippines
72.725

This shallow dish with flaring sides,
a foliated rim, and a low foot-rim is deco-
rated inside with a centralized stamped
floral design and with sketchy incised plant
motifs on the sides. A sea green glaze cov-
ers the porcelain body, except for the base.

Not illustrated.

42.
Dish
China, Ming Dynasty, 15th century
Lung-ch'üan celadon ware
Diam. 11.6 cm (4 9/16 in.)
Found in Morong, Rizal Province,
Philippines
72.566

This shallow dish with flaring sides,
a straight rim, and a low foot-rim is deco-
rated on the interior with a sketchy in-
cised design. An olive green glaze covers
the porcelain body, except for the base.

Not illustrated.

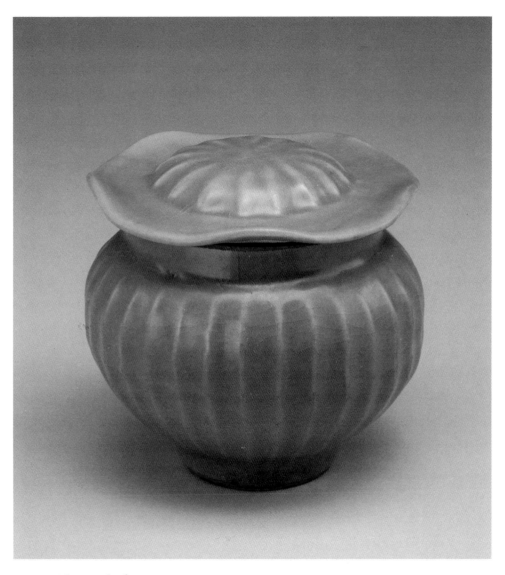

43. *Jar with Lotus-leaf Cover*

43.
Jar with Lotus-leaf Cover
China, Yüan Dynasty
Lung-ch'üan celadon ware
H. (with cover) 11.5 cm. (4 1/2 in.)
72.637

This jar has a squat, bulbous shape with a ribbed exterior, a short neck, and a low foot-rim. It was made in two horizontal sections joined at the middle. The lotus-leaf-shaped cover has a fluted top. The porcelain body is covered with a sea green glaze, except for the rim of the mouth and the underside of the cover. (For similar jars, see Aga-Oglu 1972, no. 53; and Aga-Oglu 1975, no. 19.)

44.
Jar with Lotus-leaf Cover
China, Yüan Dynasty
Lung-ch'üan celadon ware
H. (with cover) 8 cm (3 1/4 in.)
72.639

This squat jar with a ribbed exterior and a lotus-leaf-shaped cover is similar to no. 43.

Not illustrated.

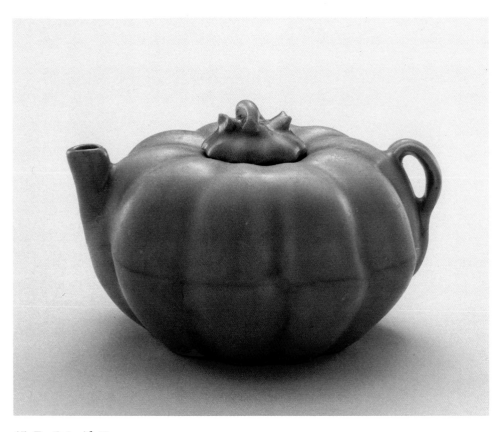

45. *Tea Pot with Cover*

45.
Tea Pot with Cover
China, Yüan Dynasty
Lung-ch'üan celadon ware
H. (with cover) 8.3 cm (3 1/4 in.)
72.672

This pumpkin-shaped tea pot was made in two sections which were joined at the middle of its squat body. It has a short spout and a slightly recessed base. The lid and handle are in the form of a pumpkin stem. Incised on the shoulder are two leaves, one on each side of the handle. The porcelain body is covered with a bluish sea green glaze, except for the base. (For similar tea pots, see Locsin 1967, pl. 121; and Aga-Oglu 1975, no. 17.)

46.
Tea Pot
China, Yüan Dynasty
Lung-ch'üan celadon ware
H. 6.5 cm (2 1/2 in.)
Found in Pila, Laguna Province, Philippines
72.671

This pumpkin-shaped tea pot with a short spout and a stem-shaped handle is of the same type as no. 45, except that it has no cover.

Not illustrated.

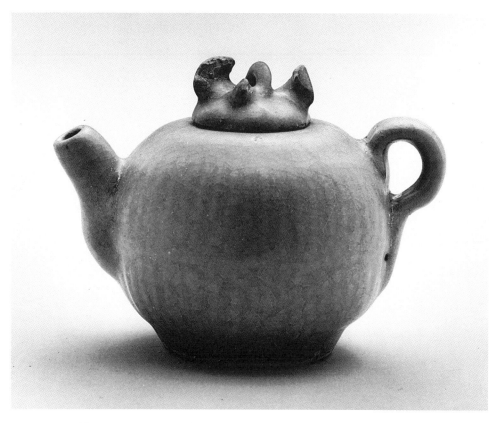

47. Tea Pot with Cover

47.
Tea Pot with Cover
China, Yüan Dynasty
Lung-ch'üan celadon ware
H. (with cover) 8.9 cm (3 1/2 in.)
72.620

This globular tea pot with a lightly fluted
exterior and a low foot-rim was made
in two sections then joined horizontally at
the middle. It has a short spout, a loop
handle, and a leaf-shaped cover. The porce-
lain body is covered with a sea green
glaze, except for the inside of the lid.

48.
Incense Burner
China, Yüan Dynasty
Bluish gray-glazed porcelain
H. 6.7 cm (2 5/8 in.)
Found in Calatagan, Batangas Province,
Philippines
72.607

This small, cylindrical incense burner has
horizontal ribbing and a flat base.
The porcelain body is covered with a blu-
ish gray, opaque glaze resembling
celadon glaze; the bottom and the base
are unglazed.

Not illustrated.

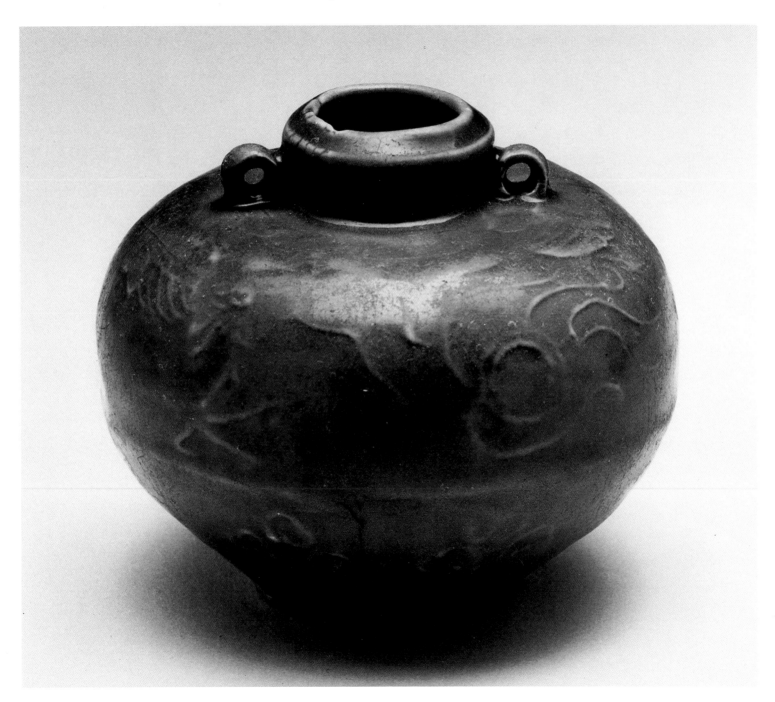

49. Jar

49.
Jar
China, Yüan Dynasty
Lung-ch'üan celadon ware
H. 9.5 cm (3 3/4 in.)
73.312

This bulbous jar has two loop handles
at the low neck and a flat, unglazed base.
It is decorated in low relief with a dragon
pursuing a flaming pearl on the shoulder
and a band of tendril scrolls above the
base. The porcelain body is covered with
an olive green glaze. (Compare Aga-Oglu
1975, no. 32.)

50.
Jar
China, Yüan Dynasty
Lung-ch'üan celadon ware
H. 10.1 cm (4 in.)
72.630

This bulbous jar with two loop handles
at the low neck and a flat, unglazed base is
related to no. 49. It is decorated in low
relief with scrolling flowers—peony, lotus,
and chrysanthemum—on the shoulder
and a band of vertical petals above the base.
The porcelain body is covered with a
sea green glaze.

Not illustrated.

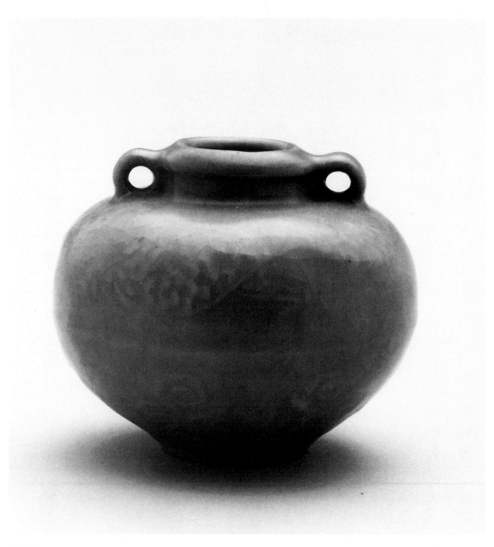

51. *Jar*

51.
Jar
China, Yüan Dynasty
Lung-ch'üan celadon ware
H. 7 cm (2 3/4 in.)
Found in Barras, Rizal Province,
Philippines
72.631

This squat, bulbous jar with two loop
handles at the low neck and a flat, unglazed
base is decorated in low relief with a
dragon pursuing a flaming pearl on the
shoulder and a band of tendril scrolls
above the base. The porcelain body is cov-
ered with a sea green glaze.
(Compare Aga-Oglu 1975, no. 32.)

52.
Jar
China, Yüan-early Ming Dynasty
Chekiang celadon ware
H. 5.7 cm (2 1/4 in.)
Found in Barras, Rizal Province,
Philippines
72.683

This squat, bulbous jar has two loop
handles at the low neck and a flat, unglazed
base. It is decorated in low relief with
chrysanthemum scrolls on the shoulder
and a band of foliated petal panels
above the base. The porcelain body is cov-
ered with a bluish green glaze.
(Compare Aga-Oglu 1972, no. 55.)

Not illustrated.

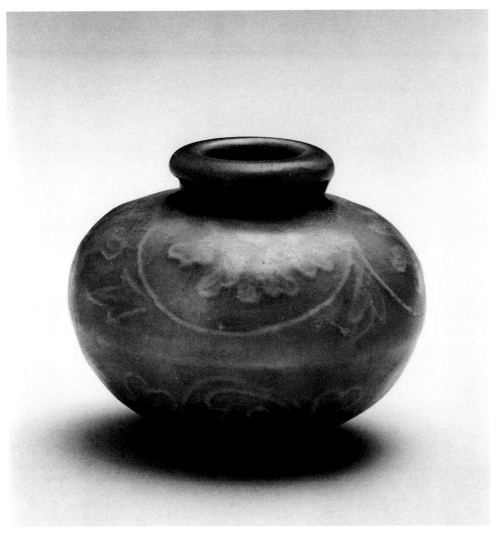

54. *Jar*

53.
Jar
China, Yüan Dynasty
Lung-ch'üan celadon ware
H. 7 cm (2 3/4 in.)
Found in Pila, Laguna Province,
Philippines
72.634

This squat, bulbous jar with loop handles
at the neck and a flat, unglazed base is
similar to no. 51, except that on the shoul-
der it has two dragons pursuing a flam-
ing pearl.

Not illustrated.

54.
Jar
China, Yüan Dynasty
Lung-ch'üan celadon ware
H. 5.2 cm (2 1/8 in.)
72.633

This squat, bulbous jar with a short neck
and a flat, unglazed base is decorated
in low relief with peonies on the shoulder
and a band of scrolls above the base.
The porcelain body is covered with a sea
green glaze. (Compare Aga-Oglu 1975,
no. 33.)

55 and 56.
Jars
China, Yüan Dynasty
Lung-ch'üan celadon ware
H. (each) 5.7 cm (2 1/4 in.)
72.632, 72.669

These two squat, bulbous jars are similar
in every respect to no. 54.

Not illustrated.

57.
Jar
China, Yüan Dynasty
Lung-ch'üan celadon ware
H. 6.3 cm (2 1/2 in.)
72.670

This jar is similar to no. 54, except that
it has a band of fluting above the base.

Not illustrated.

58.
Jar
China, Yüan Dynasty
Celadon-type ware
H. 6.3 cm (2 1/2 in.)
Found in Pila, Laguna Province,
Philippines
72.657

This ovoid jar has a short neck, a slightly
recessed, unglazed base, a porcelain body,
and a bluish gray celadon-type glaze.

Not illustrated.

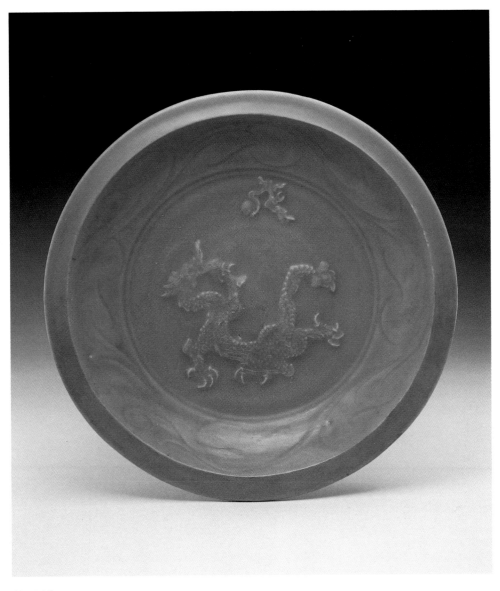

59. *Dish*

59.
Dish
China, late Sung-early Yüan Dynasty
Lung-ch'üan celadon ware
Diam. 35.6 cm (14 in.)
Found on Bohol Island, Philippines
72.692

This large dish with a flattened rim and
a low foot-rim is decorated on the inside
center with a dragon pursuing a flaming
pearl in applied relief and on the cavetto
with a band of incised foliage-scrolls.
The exterior shows a band of carved petals.
The porcelain body is covered with a
sea green glaze. A portion of the upper side
and rim of this dish has been restored.
(For similar dishes, see Lee/Ho 1968,
no. 60; and Aga-Oglu 1975, no. 25.)

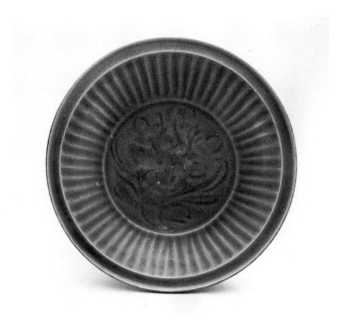

60.
Dish
China, Yüan-early Ming Dynasty,
14th century
Lung-ch'üan celadon ware
Diam. 34 cm (13 1/2 in.)
72.679

This large dish has a fluted cavetto,
a flattened rim with upturned lip, and a low
foot-rim. It is decorated on the bottom
with a large, lightly carved peony spray.
The porcelain body is covered with sea
green glaze. (Compare Aga-Oglu 1972,
nos. 58 and 59.)

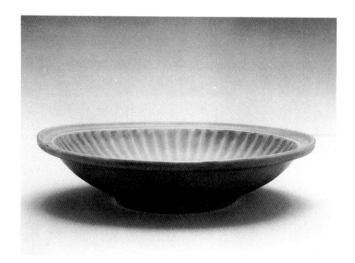

60. *Dish*

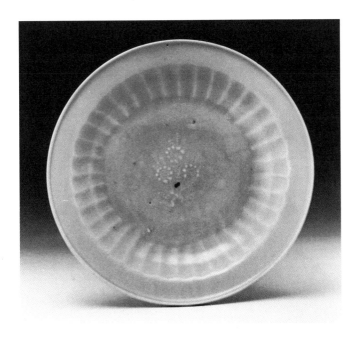

61.
Dish
China, Ming Dynasty, 16th century
Chekiang celadon ware
with white slip decoration
Diam. 33.1 cm (13 in.)
72.691

This large, heavily potted, shallow
dish has a fluted cavetto, a flattened rim
with upturned lip, and a low foot-rim.
The porcelain body is entirely covered by
a thick, sea green celadon glaze, with
coarse sand adhering to the glaze on the
base and lower portion of the exterior.
It is decorated in white slip on the inside
center with a small cluster of delicate
flowers executed in dots and fine lines. The
unusual white slip decoration in this
dish, which is undoubtedly from Chekiang,
shows the influence of the decoration
of some contemporary "Swatow" wares
(compare no. 62). (See also a Ming
celadon dish, almost identical to no. 61,
in Tokyo 1965, no. 498 [diam. 33.2 cm].)

61. *Dish*

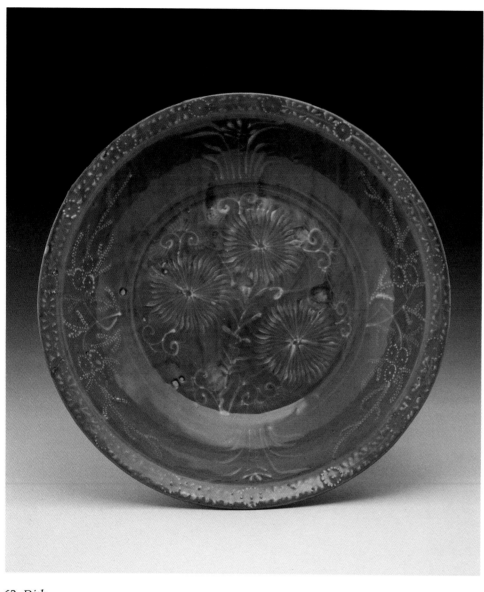

62. *Dish*

62.
Dish
China, Ming Dynasty,
second half of the 16th century
Swatow-type ware with white
slip decoration
Diam. 38.3 cm (15 1/8 in.)
73.299

This deep dish with a narrow, flattened rim and a low foot-rim has a coarse porcelain body and a glossy blue glaze. The inside is decorated in white slip with sprays of delicate flowers and feathery foliage executed in dots, drops, and fine lines. The burnt red base is mostly unglazed and has coarse sand accretions around the inner side of the glazed foot-rim. This dish represents one of the types of the so-called Swatow ware, a coarse porcelain of the sixteenth and seventeenth centuries that was made chiefly in Fukien province for export to Japan, the Philippines, and other parts of Southeast Asia. The name "Swatow" derives from one of the southern Chinese ports through which the ware was shipped abroad. (For other types of this ware, see nos. 160-161, 165-166, and 171. For related dishes, see Aga-Oglu 1972, no. 38; Aga-Oglu 1975, no. 155; Aga-Oglu 1955, fig. 34; d'Argence 1967, pl. 63E; and Tokyo 1965, nos. 495-497.)

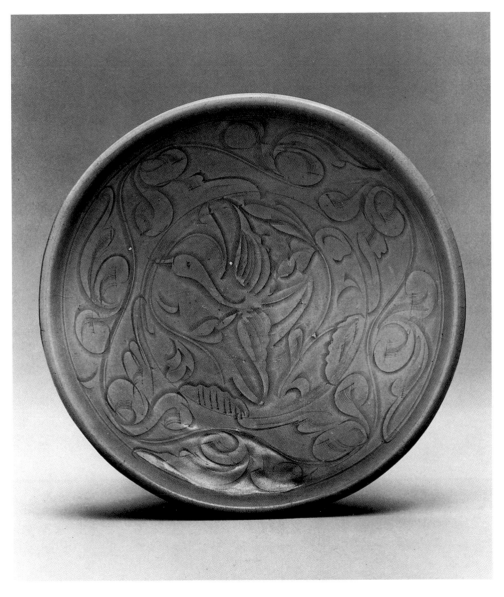

63. *Dish*

63.
Dish
China, late Sung-Yüan Dynasty
Chekiang celadon ware
Diam. 28 cm (11 in.)
73.309

This rather thinly potted, large, shallow dish has an everted lip and a low, narrow foot-rim. On the inside, covering the entire surface, is a boldly carved decoration of a large flying goose amid scrolling foliage. The grayish white porcelain body is covered with a rather thin, glossy, olive brown glaze, except for the base.

64.
Dish
China, probably early Ming Dynasty
Celadon-type ware
Diam. 29.6 cm (11 5/8 in.)
72.666

This rather thinly potted, shallow dish with a flaring rim and a narrow foot-rim is decorated on the interior with two incised lotus flowers and foliage. On the exterior are slanting grooves. The porcelain body is covered with a thin, olive brown celadon-type glaze, except for the base. On the inside center of the dish, over the glaze, are four prominent spur marks.

Not illustrated.

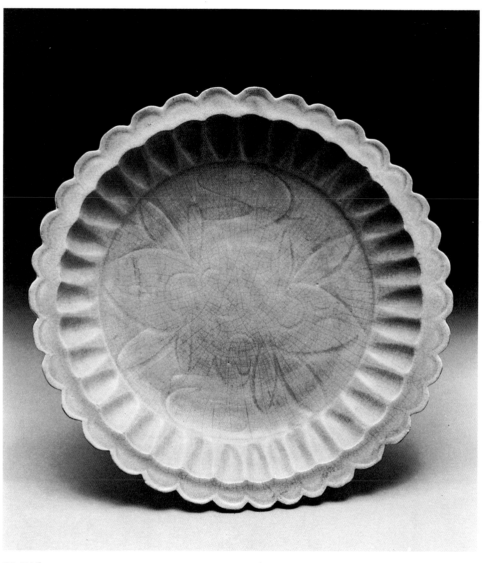

65. *Dish*

65.
Dish
China, late Ming Dynasty
Lung-ch'üan celadon ware
Diam 35.7 cm (14 1/16 in.)
72.627

This large dish, fluted inside and out, has a flattened, scalloped rim and a low foot-rim. It is decorated on the bottom with two incised lotus flowers. The porcelain body is covered with a sea green glaze, except for a ring around the center of the base. Portions of the inside center and upper part of the side show evidence of restoration.

Not illustrated.

66.
Dish
China, Ming Dynasty
Lung-ch'üan celadon ware
Diam. 33.2 cm (13 1/16 in.)
73.321

The inside of this large, shallow dish with a straight rim and a low foot-rim is decorated on the bottom with a stamped peony spray bordered by a combed wave design. On the cavetto is a band of carved waves. A glossy, sea green glaze covers the porcelain body, except for a ring around the center of the base.

Not illustrated.

67.
Dish
China, Ming Dynasty
Celadon-type ware
Diam. 35.5 cm (14 in.)
72.693

This large, shallow dish has a straight rim and a low foot-rim. The interior is decorated at the bottom with an incised peony spray. The porcelain body is covered with a glossy, green celadon-type glaze, except for the base.

Not illustrated.

68.
Dish
China, Ming Dynasty
Lung-ch'üan celadon ware
Diam. 27 cm (10 5/8 in.)
72.690

This shallow dish has a straight rim and a low foot-rim. The interior is decorated at the bottom with an incised lotus. The porcelain body is covered with a pale sea green glaze, except for a ring around the recessed circular center of the base.

Not illustrated.

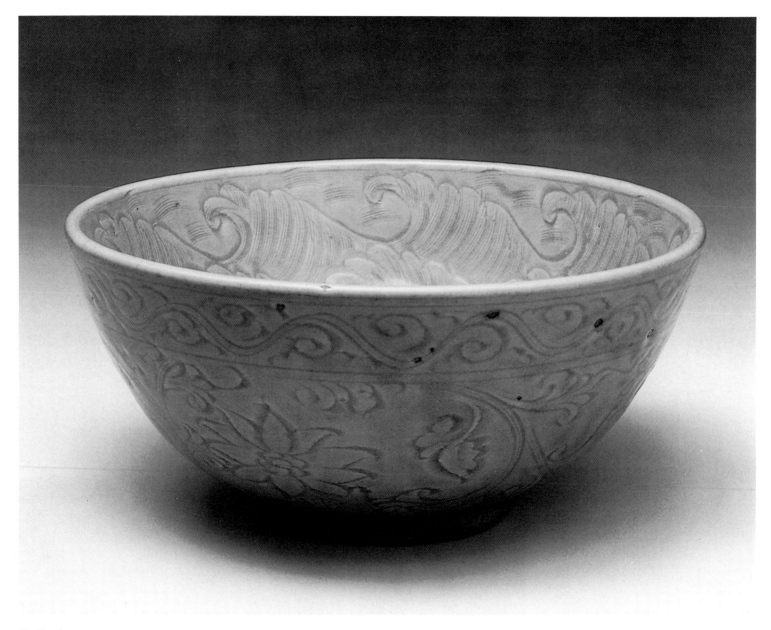

69. Bowl

69.
Bowl
China, Ming Dynasty, 15th century
Celadon ware
Diam. 30 cm (11 3/4 in.)
73.338

This large, deep bowl with a straight
rim and a low foot-rim is decorated on the
interior with an incised, allover wave
design around a central rosette. On the ex-
terior below the rim are an incised
scroll border and a band of scrolling foli-
age connecting a lotus and a peony.
The porcelain body is covered with a pale
sea green glaze, except for the base
which shows a thin wash of glaze on its
recessed center. (Compare Pope 1956,
pl. 127.)

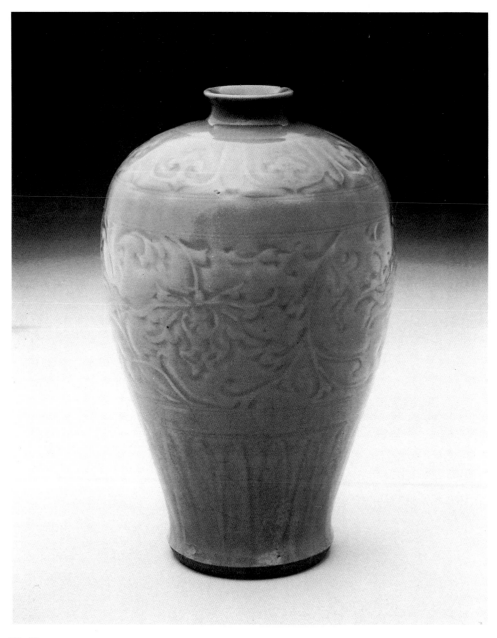

70. *Vase*

70.
Vase
China, late Ming Dynasty
Celadon ware
H. 30.6 cm (12 in.)
73.337

This vase is of the *mei-p'ing* (plum blossom) shape with a high shoulder, a narrow neck, and a low foot-rim beveled on the outside. The lightly carved decoration consists of a trefoil border on the shoulder, a band of peony scrolls around the main body, and a row of tall vertical petals above the base. The porcelain body is covered with a pale sea green glaze, including the base.

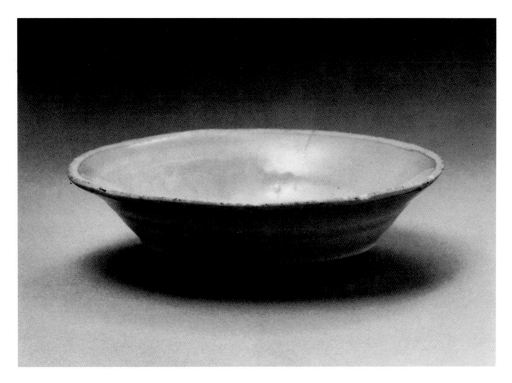

71.
Dish
China, Yüan Dynasty
Ch'ing-pai ware
Diam. 11.4 cm (4 1/2 in.)
72.681

This deep dish has a flaring rim, angular sides, and a very low, thin foot-rim. It is decorated on the inside with a thunder-pattern border and a band of petals molded in low relief. The porcelain body is covered with a translucent, pale blue *ch'ing-pai* glaze, except for the edge of the rim and the base. (For a *shu-fu* dish of similar shape, see Aga-Oglu 1975, no. 48 [right].)

71. *Dish*

72.
Bowl
China, Yüan Dynasty
Ch'ing-pai-type ware
Diam. 17.2 cm (6 3/4 in.)
72.580

This deep bowl with a foliated rim has
a low, circular pedestal base with a slightly
raised edge. It is decorated on the inte-
rior with a molded design of eight foliated
panels enclosing symbolic emblems. The
porcelain body is covered with a glossy,
grayish white glaze, except for the base.

Not illustrated.

73.
Dish
China, late Sung Dynasty
Ch'ing-pai-type ware
Diam. 3.9 cm (5 1/2 in.)
72.596

This shallow dish has an unglazed rim
and a very low, thin foot-rim around a flat,
unglazed base. In the center of the in-
terior is a pair of fish in low relief. The por-
celain body is covered with a grayish
pale blue glaze which covers the exterior
unevenly, exposing parts of the sides.

Not illustrated.

74.
Dish
China, late Sung Dynasty
Ch'ing-pai-type ware
Diam. 13.9 cm (5 1/2 in.)
72.595

This shallow dish has an unglazed
rim and a slightly recessed, unglazed base.
In the center of the interior is a pair of
fish in very indistinct low relief. The porce-
lain body is covered with a pale blue
glaze which stops unevenly on the exte-
rior, exposing parts of the sides.

Not illustrated.

75.
Dish
China, late Sung Dynasty
Ch'ing-pai-type ware
Diam. 13.9 cm (5 1/2 in.)
72.597

This shallow dish with a concave,
unglazed base, has a porcelain body cov-
ered with a glossy, pale blue glaze.

Not illustrated.

76.
Dish
China, probably early Ming Dynasty
Ch'ing-pai-type ware
Diam. 16.5 cm (6 1/2 in.)
Found in Lumbang, Laguna Province,
Philippines
72.682

This shallow dish has a flaring, scalloped
rim and a very low foot-rim. The rim
is decorated with a floral band in relief.
The porcelain body is covered with a
glossy, pale blue glaze, except for the base.
This dish was warped in firing.

Not illustrated.

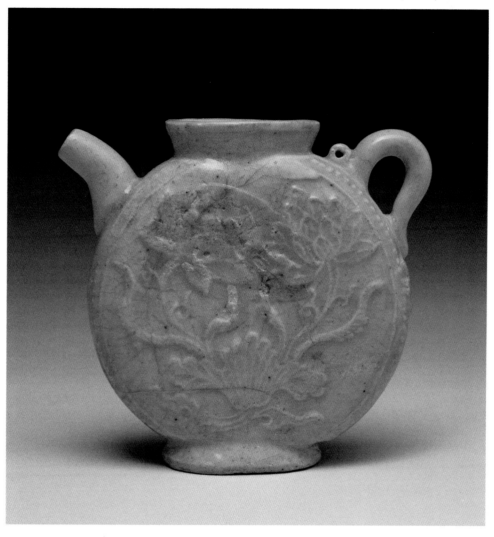

77. *Ewer*

77.
Ewer
China, Yüan Dynasty
Ch'ing-pai ware
H. 11.5 cm (4 1/2 in.)
Found in Lumbang, Laguna Province,
Philippines
72.605

This flask-shaped ewer with a flattened
oval body, ovoid mouth, and sturdy
foot-rim was molded in two vertical sec-
tions and joined at the narrow sides.
It has a short spout and curved handle with
a small loop for attaching the cover,
which is missing. It is decorated on each
side in low relief with a lotus spray
framed by a string of beading in relief.
A pale blue *ch'ing-pai* glaze covers
the porcelain body, except for the base.

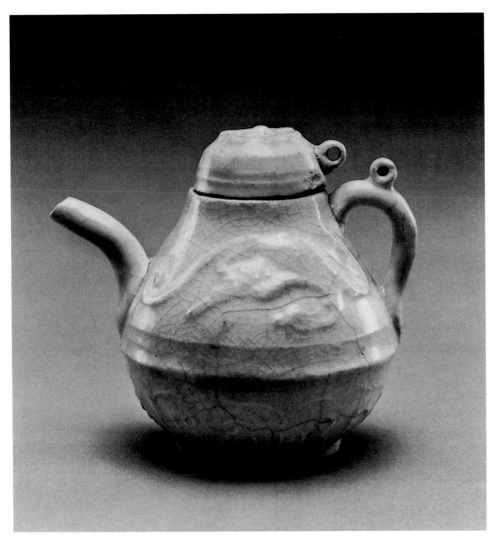

78. *Ewer with Cover*

78.
Ewer with Cover
China, Yüan Dynasty
Ch'ing-pai ware
H. (with cover) 9.6 cm (3 3/4 in.)
Found in Lumbang, Laguna Province,
Philippines
72.600

This pear-shaped ewer has a rounded
handle, a curving spout, and a flat,
unglazed base. The main body was molded
in two horizontal sections and joined
at a clearly visible ridge. It is decorated in
relief with a flying phoenix on each side
above a border of foliate petal panels. Small
loops are attached to the handle and
cover to connect them. The porcelain body
is covered with a pale blue *ch'ing-pai* glaze.

79. *Box with Cover*

79.
Box with Cover
China, Sung Dynasty
Ch'ing-pai-type ware
H. (with cover) 3.6 cm (1 3/8 in.),
Diam. 6 cm (2 3/8 in.)
72.618

This covered box has fluted sides and a small molded flower in the center of its cover. The porcelain body is covered with a pale bluish white *ch'ing-pai*-type glaze, except for the flat base which shows four spur marks.

80. *Bowl*

80.
Bowl
China, Yüan Dynasty
Ch'ing-pai ware
Diam. 7.6 cm (3 in.)
72.602

This deep bowl, with an unglazed rim and a flat, unglazed base, has a porcelain body and is covered with a translucent, pale blue *ch'ing-pai* glaze. On the exterior is a molded decoration of four foliate medallions, each containing a Chinese character: *fu kuei ch'ang ming.* Taken all together, the characters may be translated as "prosperity and success." (For related bowls, without characters, see Aga-Oglu 1975, no. 49.)

81.
Bowl
China, Yüan Dynasty
Ch'ing-pai ware
Diam. 7.6 cm (3 in.)
72.601

This deep porcelain bowl, with an unglazed rim and a flat, unglazed base, is covered with a pale blue *ch'ing-pai* glaze. On the exterior is a molded decoration of a leaf-pattern border, below which is a band of scrolling volutes. This bowl is similar to no. 80, except that it has no inscription.

Not illustrated.

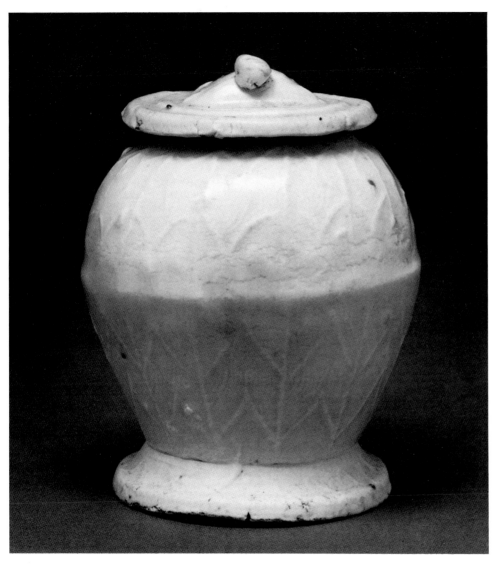

82. *Jar with Cover*

82.
Jar with Cover
China, Yüan Dynasty
Ch'ing-pai ware
H. (with cover) 8.9 cm (3 1/2 in.)
72.577

This ovoid jar with a spreading foot-rim was molded in two horizontal sections joined at the middle. The exterior is decorated with stiff petals in low relief, and the flat cover is topped by a molded figure of a tortoise with its head raised. A pale blue *ch'ing-pai* glaze covers the porcelain body, except for the base.

83.
Jar with Cover
China, Yüan Dynasty
Shu-fu-type ware
H. (with cover), 8.9 cm (3 1/2 in.)
72.599

This ovoid jar has a wide mouth-rim and a flat, unglazed base. It is decorated in relief with floral scrolls on the shoulder and a row of inverted petal panels above the base. The cover, with a central knob, is decorated with petal borders in low relief. The porcelain body is covered with an opaque, pale blue *shu-fu*-type glaze.

Not illustrated.

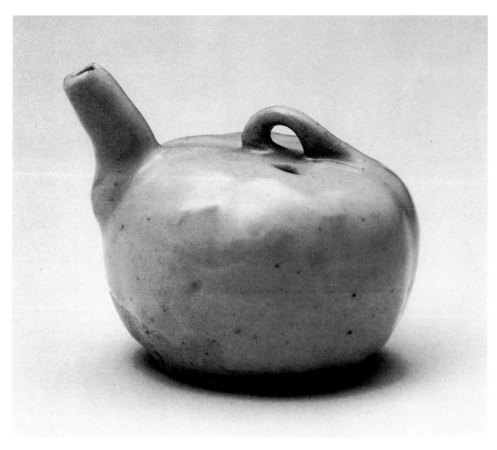

85. *Water Dropper*

84.
Jar with Cover
China, Yüan Dynasty
Ch'ing-pai ware
H. (with cover), 10.2 cm (4 in.)
72.578

This small, ovoid jar has a lightly fluted exterior, a spreading foot-rim, and a small domed cover with a central knob. The main body was molded in two horizontal sections joined at the middle. A translucent, pale blue *ch'ing-pai* glaze covers the porcelain body.

Not illustrated.

85.
Water Dropper
China, Yüan Dynasty
Ch'ing-pai ware
H. 5.7 cm (2 1/4 in.)
72.603

This pumpkin-shaped water dropper has a short spout and a loop handle at the top, next to a small hole used to fill the vessel. On the shoulder is an indistinct leaf design molded in low relief. The porcelain body is covered with a *ch'ing-pai* glaze, except for the flat base.

Water droppers are used in the preparation of ink.

86.
Water Dropper
China, Yüan Dynasty
Bluish gray-glazed porcelain
H. 5.4 cm (2 1/8 in.)
72.592

This small, cone-shaped water dropper,
with a short spout and a small hole at the
top for filling, is covered with a mottled,
bluish gray glaze, except for the platform
base.

Not illustrated.

87.
Water Dropper
China, Yüan Dynasty
Celadon-type glazed porcelain
H. 4.5 cm (1 3/4 in.)
72.590

This small, cone-shaped water dropper
with a short spout, a loop handle, and
a small hole near the top is covered with
a greenish gray celadon-type glaze,
except for the platform base.

Not illustrated.

88.
Seated Figure
China, Yüan Dynasty
Ch'ing-pai ware
H. 7.6 cm (3 in.)
72.606

The porcelain body of this roughly
molded figure of a seated boy holding a
lotus flower over his head is covered
with a *ch'ing-pai* glaze. (For a similar figure,
see Aga-Oglu 1975, no. 69.)

Not illustrated.

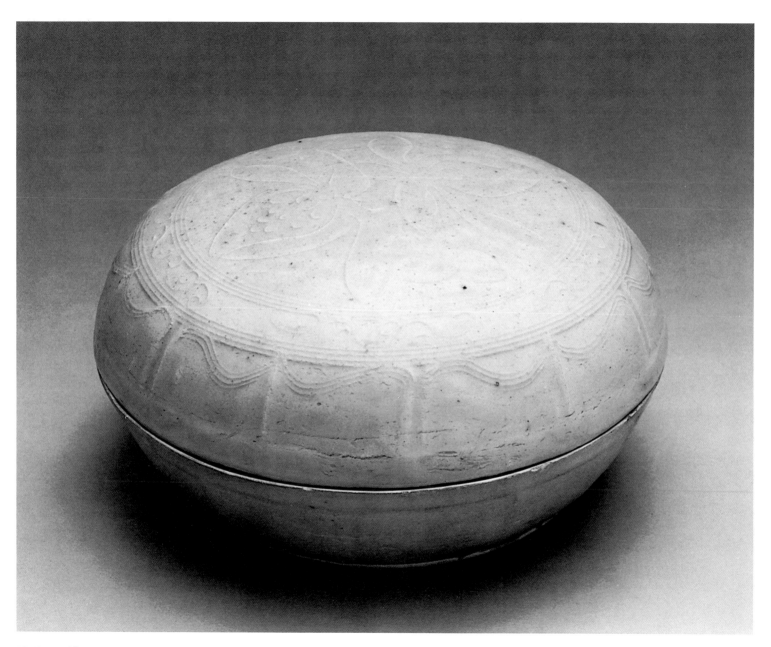

89. Box with Cover

89.
Box with Cover
China, Yüan Dynasty
White ware
H. (with cover) 10.8 cm (4 1/4 in.),
Diam. 20.3 cm (8 1/4 in.)
72.608

This round box with cover has curving,
paneled sides and a slightly concave base.
The center of the low-domed cover is
decorated in molded relief with two lotus
buds bordered by a band of scrolls.
The fine-grained white porcelain body is
covered with a faintly bluish, trans-
parent glaze, except for the base.

Nos. 89-103 are probably from the kilns
of Te-hua in Fukien province. Vessels from
Te-hua have fine-grained white porce-
lain bodies and are covered with a thin,
transparent glaze which in most pieces
has a creamy white tone but at times has
a bluish or grayish cast. (For related
vessels, see Aga-Oglu 1975, nos. 78-96.)

90.
Box with Cover
China, Yüan Dynasty
White ware
H. (with cover) 3.5 cm (1 3/8 in.),
Diam. 8.2 cm (3 1/4 in.)
72.583

This round box has a sloping lower
portion and a curving, low-domed cover.
It is decorated with bands of scrolls
molded in low relief. The fine porcelain
body is covered with a transparent,
cream-toned glaze, except for the slightly
concave base.

Not illustrated.

91.
Box with Cover
China, Yüan Dynasty
White ware
H. (with cover) 3.8 cm (1 1/2 in.),
Diam. 8.5 cm (3 3/8 in.)
72.582

This round box with cover is almost
identical to no. 90 (the cover of this box
has been repaired).

Not illustrated.

92.
Vase
China, Yüan Dynasty
White ware
H. 8.8 cm (3 1/2 in.)
72.579

This small, ovoid vase with a trumpet-
shaped neck and a spreading foot is deco-
rated with two bands of overlapping
petals molded in low relief. The porcelain
body is covered with a faintly bluish,
transparent glaze, except for the base.

Not illustrated.

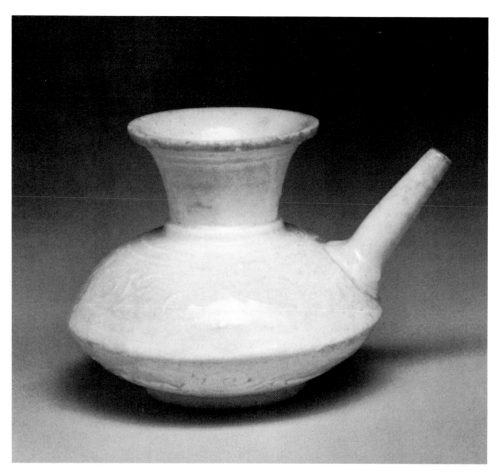

94. *Kendi Vessel*

93.
Wine or Sauce Pot
China, Yüan Dynasty
White ware
H. (with cover) 7.9 cm (3 1/8 in.)
72.674

This wine or sauce pot with fluted, curving sides, a short neck, and a concave base was molded in two horizontal sections that are joined at the middle. It has a loop handle, a curving spout, and a flat-topped cover. The porcelain body is covered with a transparent, blue-tinged glaze, except for the base.

Not illustrated.

94.
Kendi Vessel
China, Yüan Dynasty
White ware
H. 11.1 cm (4 3/8 in.)
72.569

This squat *kendi* drinking vessel has a flat, unglazed base, a trumpet-shaped neck, and a straight spout. The main body was molded in two horizontal sections in the form of shallow bowls that have been luted together at their rims. On the sides are two bands of scrolls molded in low relief. The porcelain body is covered with a transparent, cream-toned glaze.

95.
Kendi Vessel
China, Yüan Dynasty
White ware
H. 11.1 cm (4 3/8 in.)
72.568

This *kendi* drinking vessel is of the same type as no. 94.

Not illustrated.

96.
Bowl
China, Yüan Dynasty
White ware
Diam. 18.4 cm (7 1/4 in.)
72.648

This heavily potted bowl with a flaring rim and a flat base is decorated on the interior with a band of lotus flowers molded in low relief. The porcelain body is covered with a thin, grayish white glaze, except for the rim and the base.

Not illustrated.

97.
Bowl
China, Yüan Dynasty
White ware
Diam. 12.7 cm (5 in.)
72.574

This deep bowl with a straight rim and a flat base has on its exterior a molded decoration in the form of a band of stiff, overlapping petals. A transparent glaze in a creamy white tone covers the porcelain body, except for the rim and the base.

Not illustrated.

98.
Bowl
China, Yüan Dynasty
White ware
Diam. 12.4 cm (4 7/8 in.)
Found in Calatagan, Batangas Province, Philippines
72.651

This deep bowl with a straight rim and a flat base is decorated on the exterior with a row of stiff petals. The porcelain body is covered with a transparent, creamy white glaze, except for the rim and the base.

Not illustrated.

99.
Bowl
China, Yüan Dynasty
White ware
Diam. 8.9 cm. (3 1/2 in.)
72.649

This deep bowl, with an unglazed rim and base and a molded decoration of stiff petals, is similar to nos. 97 and 98.

Not illustrated.

100.
Bowl
China, Yüan Dynasty
White ware
Diam. 8.5 cm (3 3/8 in.)
72.594

This deep bowl, with an unglazed rim
and base and a molded decoration of stiff
petals, is similar to nos. 97 and 98.

Not illustrated.

101 and 102.
Bowls
China, Yüan Dynasty
White ware
Diam. (each) 11.5 cm (4 1/2 in.)
72.575, 72.650

These two deep bowls with unglazed
rims and bases and molded decorations
of stiff petals are similar to nos. 97 and 98.

Not illustrated.

103.
Bowl
China, Yüan Dynasty
White ware
Diam. 14.3 cm (5 5/8 in.)
72.598

This deep bowl with unglazed rim and
base and a molded decoration of stiff petals
is similar to nos. 97 and 98.

Not illustrated.

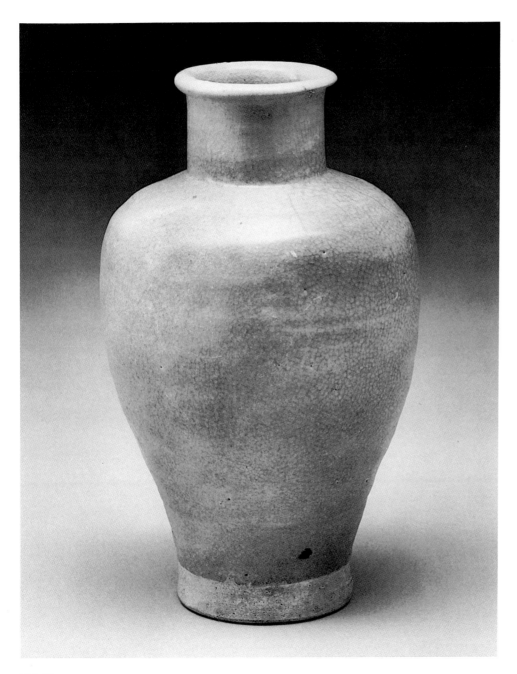

104.
Vase
China, late Sung-early Yüan Dynasty
Celadon-type ware
H. 21 cm (8 1/4 in.)
Found in Laguna Province,
Philippines
72.658

This ovoid porcelain vase with a high,
cylindrical neck, an everted lip, and a con-
cave base is covered with a crackled, bluish
gray celadon-type glaze which stops on
the exterior in an even line above the base.

104. *Vase*

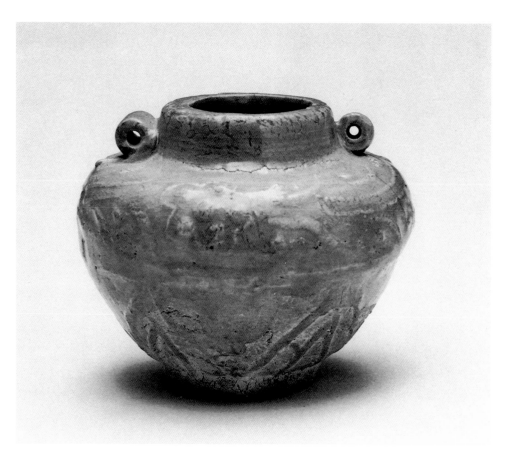

105.
Jar
China, Yüan Dynasty
Gray stoneware
H. 6 cm (2 3/8 in.)
72.656

This small, ovoid jar with a low foot-rim and two loop handles at the low neck is decorated in relief with floral scrolls on the shoulder and a band of stiff petals near the base. It is covered with a thin, glossy, gray glaze which stops on the exterior in an uneven line above the foot.

Nos. 105-113 belong to a distinct type of stoneware in which the body and glaze of most pieces are gray in color. This ordinary ware was made in southern kilns from the Sung period on, for markets at home and abroad, and was especially popular in Southeast Asia.

105. *Jar*

106.
Jar
China, Yüan Dynasty
Gray stoneware
H. 6 cm (2 3/8 in.)
72.655

This small, globular jar has a flat base,
a wide mouth-rim, and two small loops at
the shoulder. It is covered with a thin,
glossy, gray glaze which stops unevenly
on the exterior above the base.

Not illustrated.

107.
Bowl
China, Southern Sung Dynasty
Gray stoneware
Diam. 10.1 cm (4 in.)
72.652

This small, cylindrical bowl with a low
foot-rim is decorated on the exterior with
combed vertical grooves. It is covered
with a thin, glossy, gray glaze which stops
unevenly on the exterior above the
foot-rim.

Not illustrated.

108. *Bowl*

108.
Bowl
China, Southern Sung Dynasty
Gray stoneware
Diam. 16.7 cm (6 5/8 in.)
72.643

This deep bowl has rounded sides,
a slightly everted rim, and a thick, narrow
foot-rim around a roughly trimmed
base. On the interior it is decorated with
an incised floral band and on the exterior
with clusters of combed vertical grooves.
It is covered with a glossy, thin, gray
glaze which stops unevenly at the lower
portion of the exterior.

109.
Bowl
China, Southern Sung Dynasty
Gray stoneware
Diam. 17.1 cm (6 3/4 in.)
72.644

This deep bowl with rounded sides has
a straight rim and a thick, narrow foot-rim
around a roughly trimmed, convex
base. On the interior is an incised decora-
tion of two lotus buds between two
sprays of foliage. It is covered with a glossy,
thin, gray glaze which stops unevenly
at the lower portion of the exterior.

Not illustrated.

110.
Bowl
China, Southern Sung Dynasty
Gray stoneware
Diam. 17.8 cm (7 in.)
72.593

This deep bowl with rounded sides
has a straight rim and a sturdy foot-rim
and is decorated on the interior with
a lightly incised, sketchy wave design. The
body is covered with a thin, mottled,
brownish gray glaze which stops at the
lower portion of the exterior.

Not illustrated.

111.
Bowl
China, probably late Sung Dynasty
Gray stoneware
Diam. 16.5 cm (6 1/2 in.)
Found in Victoria, Mindoro Island,
Philippines
72.589

This shallow bowl has an everted rim,
a narrow, neatly trimmed foot-rim, and a
slightly convex base. It is decorated
on the inside with a narrow, molded band
of foliage set above clusters of straight
fluting. There is an unglazed ring around
the glazed center of the bottom. It is
covered with a slightly greenish gray glaze
which stops unevenly above the foot-rim.

Not illustrated.

112 and 113.
Dishes
China, Southern Sung Dynasty
Gray stoneware
Diam. (each) 18.7 cm (7 3/8 in.)
72.586, 72.587

These shallow dishes with flattened
rims and low foot-rims are covered with
a thin gray glaze which stops unevenly
on the exterior above the feet. There is an
unglazed ring around the center of the
bottom of each dish.

Not illustrated.

114.
Bowl
China, perhaps late Sung,
or Yüan, Dynasty
Porcelain
Diam. 19 cm (7 1/2 in.)
Found in Pila, Laguna, Philippines
72.588

Decorated on the inside with incised
sketchy foliage, this bowl is conical
in shape with a six-lobed rim, a narrow
foot-rim, and a slightly convex base. The
porcelain body is covered with a glossy,
pale grayish blue glaze which stops
unevenly on the exterior.

Not illustrated.

115.
Kendi Vessel
China, Yüan Dynasty
Gray-glazed porcelain
H. 16.5 cm (6 1/2 in.)
72.654

This *kendi* drinking vessel has a bulbous
body, a tall neck with a flanged mouth-
rim, and a straight spout. The main body
is decorated with a dragon molded in
low relief. A gray glaze, partially deteri-
orated, covers the vessel, except for
the base.

Not illustrated.

116.
Kendi Vessel
China, Yüan Dynasty
Gray stoneware
H. 16.5 cm (6 1/2 in.)
72.659

This rounded *kendi* drinking vessel has
a tall neck with a beveled mouth-rim and
a straight spout. A thin gray glaze with
blackish streaks and specks covers the ves-
sel, except for the upper part of the
neck and the base.

Not illustrated.

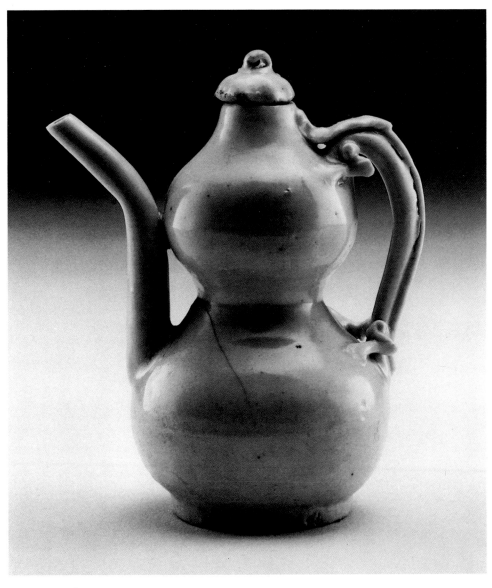

117. *Ewer with Cover*

117.
Ewer with Cover
China, Yüan Dynasty
Ch'ing-pai ware
H. (with cover) 13.4 cm (5 1/4 in.)
72.604

This double-gourd-shaped ewer has a long curving spout, a dragon-shaped handle, and a small domed cover with a loop. The porcelain body is covered with a translucent, pale blue *ch'ing-pai* glaze, except for the flat base.

The double-gourd-shaped ewers represented here (nos. 117-121) were molded in two hemispherical parts, the upper and lower gourds, that were then luted together at the narrow waist. The handle and spout were later attached to opposite sides of the vessel. (For similar double-gourd-shaped ewers, see Aga-Oglu 1972, no. 1; and Aga-Oglu 1975, nos. 97-101.)

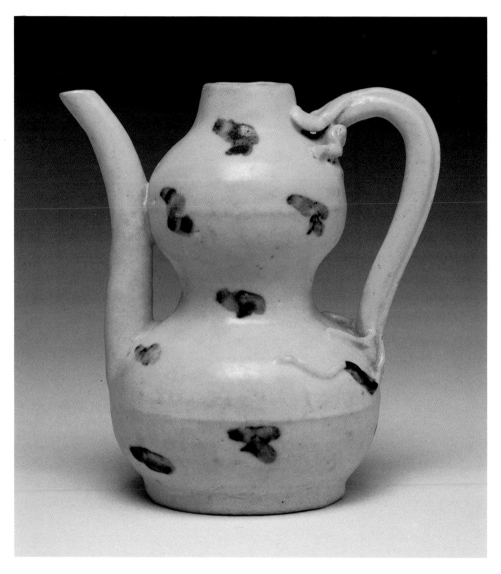

118. *Ewer*

118.
Ewer
China, Yüan Dynasty
Spotted *ch'ing-pai* ware
H. 13.3 cm (5 1/4 in.)
72.646

This double-gourd-shaped ewer has a long curving spout and a dragon-shaped handle. It is covered with a translucent, pale blue *ch'ing-pai* glaze, dabbed with iron brown spots. The flat base is unglazed.

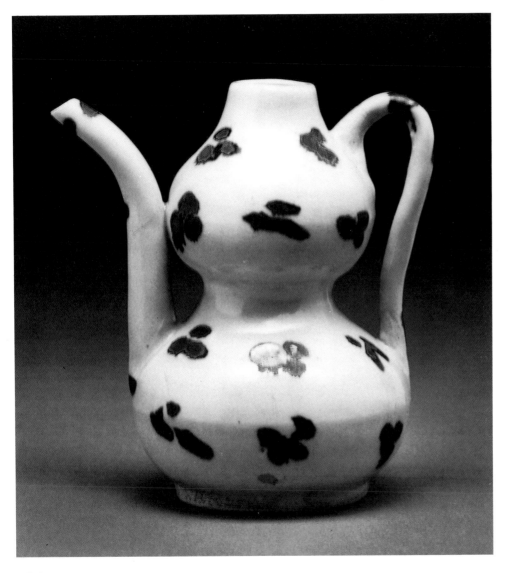

119. *Ewer*

119.
Ewer
China, Yüan Dynasty
Spotted *ch'ing-pai* ware
H. 11.1 cm (4 3/8 in.)
72.616

This double-gourd-shaped ewer has
a long curving spout, a plain handle, and
a flat, unglazed base. The porcelain
body is covered with a translucent, pale
blue *ch'ing-pai* glaze, dabbed with
iron brown spots.

120.
Ewer
China, Yüan Dynasty
Spotted *ch'ing-pai* ware
H. 12.7 cm (5 in.)
72.617

This double-gourd-shaped ewer is similar
to no. 118.

Not illustrated.

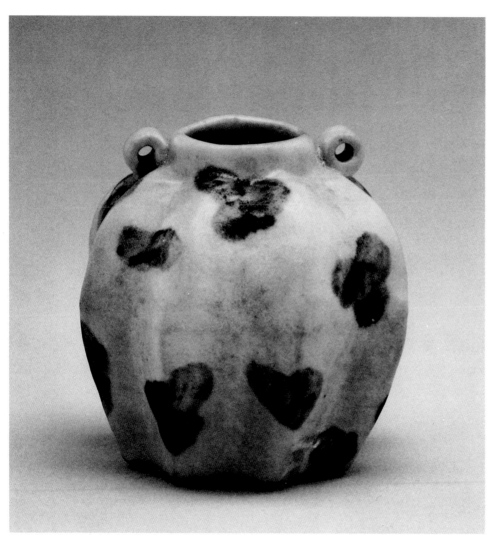

122. *Jar*

121.
Ewer
China, Yüan Dynasty
Spotted *ch'ing-pai* ware
H. 11.5 cm (4 1/2 in.)
72.615

This double-gourd-shaped ewer is similar in every respect to no. 119.

Not illustrated.

122.
Jar
China, Yüan Dynasty
Spotted *ch'ing-pai* ware
H. 6 cm (2 3/8 in.)
72.610

This small, ovoid jar has a fluted body, a short neck with two loops, and a flat, unglazed base. The porcelain body is covered with a *ch'ing-pai* glaze dabbed with iron brown spots. (For small jars of spotted and early blue-and-white wares similar to nos. 122-132, see Aga-Oglu 1972, nos. 5-7; and Aga-Oglu 1975, nos. 103-111.)

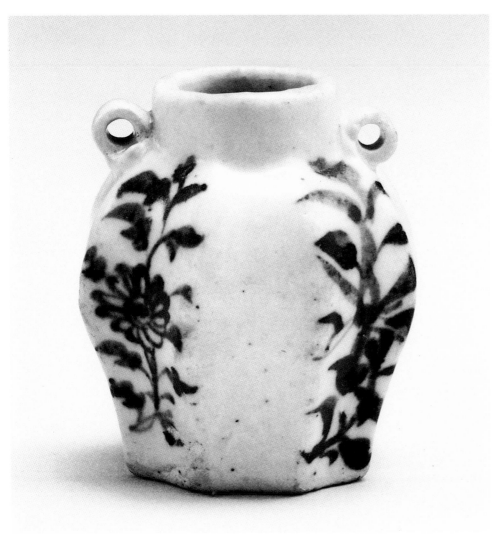

124. *Jar*

123.
Jar
China, Yüan Dynasty
Spotted ware
H. 6.4 cm (2 1/2 in.)
72.609

This small, ovoid jar with a fluted body, a short neck with two loops, and a flat, unglazed base is covered with an opaque, pale blue *shu-fu*-type glaze, which is dabbed with iron brown spots.

Not illustrated.

124.
Jar
China, Yüan Dynasty
Early blue-and-white ware
H. 5.7 cm (2 1/4 in.)
72.687

This small jar has an ovoid, fluted body, a short neck with two loops, and a flat, unglazed base. The porcelain body is decorated with vertical sprays of chrysanthemums, painted freely in grayish blue, and covered with a bluish white glaze.

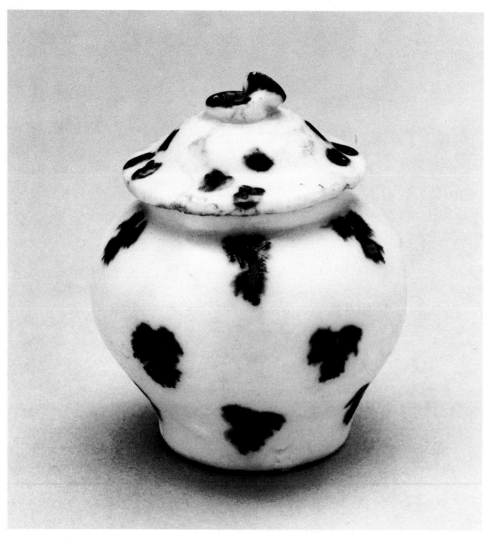

126. *Jar with Cover*

125.
Jar
China, Yüan Dynasty
Early blue-and-white ware
H. 5.7 cm (2 1/4 in.)
Found in Lumbang, Laguna Province,
Philippines
72.685

This small jar is similar in shape and
decoration to no. 124.

Not illustrated.

126.
Jar with Cover
China, Yüan Dynasty
Spotted *ch'ing-pai* ware
H. (with cover) 6.7 cm (2 5/8 in.)
72.613

This small, squat, bulbous jar has a flat,
unglazed base, a short neck, and a cover
in the shape of a lotus leaf with stem.
The porcelain body is covered by a *ch'ing-
pai* glaze dabbed with iron brown spots.

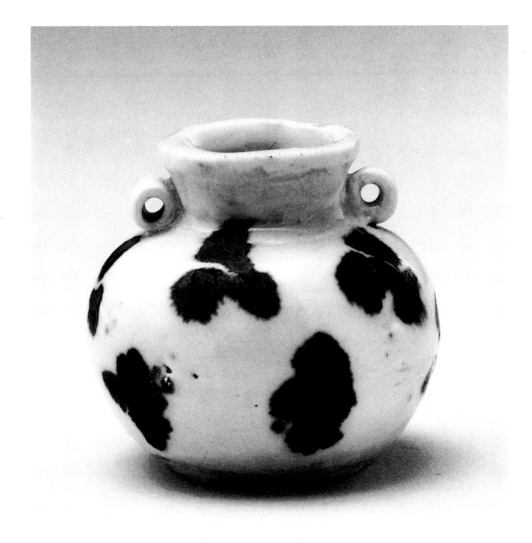

127.
Jar with Cover
China, Yüan Dynasty
Spotted *ch'ing-pai* ware
H. (with cover) 6 cm (2 3/8 in.)
72.612

This small jar with cover is similar
to no. 126.

Not illustrated.

128.
Jar
China, Yüan Dynasty
Spotted *ch'ing-pai* ware
H. 5.7 cm (2 1/4 in.)
72.614

This small, globular jar has a short neck
with two loops and a flat, unglazed base.
An iron-spotted *ch'ing-pai* glaze covers
the porcelain body.

128. *Jar*

129.
Jar
China, Yüan Dynasty
Spotted *ch'ing-pai* ware
H. 5.7 cm (2 1/4 in.)
72.611

This small, globular jar is similar to no. 128.

Not illustrated.

130.
Jar
China, Yüan Dynasty
Early blue-and-white ware
H. 5.7 cm (2 1/4 in.)
72.724

This small, globular jar with a flat, unglazed base and a short neck with two loops is decorated with chrysanthemum sprays, painted freely in grayish blue. The porcelain body is covered with a bluish white glaze.

130. *Jar*

131 and 132.
Jars
China, Yüan Dynasty
Early blue-and-white ware
H. (each) 6 cm (2 3/8 in.)
72.684, 72.686

These small, globular jars are similar
to no. 130.

Not illustrated.

133. *Dish*

133.
Dish
China, Ming Dynasty, 15th century
Blue-and-white ware
Diam. 12.4 cm (4 7/8 in.)
72.709

This dish with rounded sides and a straight rim has a hollow base with an unglazed ring around its edge. It is decorated in the center of the interior with a figure of *Shou-hsing,* framed by the character *shou* (longevity), which is painted in grayish blue. On the exterior is a band of sketchy weed design. The porcelain body is covered with a bluish white glaze.

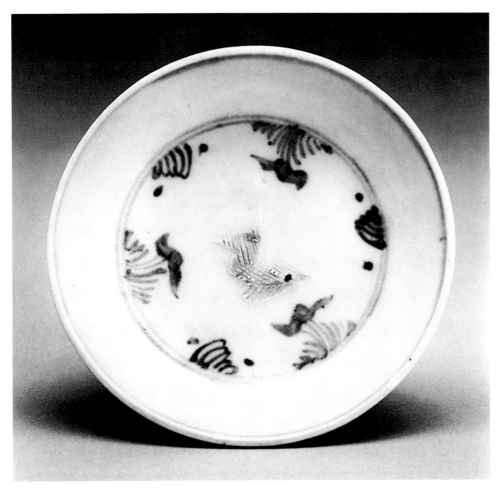

134. *Dish*

134.
Dish
China, Ming Dynasty, 15th century
Blue-and-white ware
Diam. 12.4 cm (4 7/8 in.)
Found in Rizal Province, Philippines
72.699

This dish with a straight rim and rounded sides has a hollow base with an unglazed ring around its edge. It is decorated only on the inside center with a fish in relief biscuit, burned orange in firing, which is surrounded by sketchy water plants painted in grayish blue. The porcelain body is covered with a bluish white glaze. (For similar dishes, see Locsin 1967, pl. 88; Aga-Oglu 1972, no. 17; and Aga-Oglu 1975, no. 118.)

135.
Dish
China, Ming Dynasty, 15th century
Blue-and-white ware
Diam. 12.4 cm (4 7/8 in.)
72.700

This hollow-based dish is similar in every
respect to no. 134.

Not illustrated.

136.
Dish
China, Ming Dynasty, 15th century
Blue-and-white ware
Diam. 12 cm (4 3/4 in.)
72.708

This hollow-based dish is similar in
almost every respect to no. 133, except for
the plant motif in the center of the interior.

Not illustrated.

137.
Dish
China, Ming Dynasty,
late 15th-early 16th century
Plain white ware
Diam. 12.4 cm (4 7/8 in.)
72.704

This hollow-based, undecorated dish
is related to nos. 133-136.

Not illustrated.

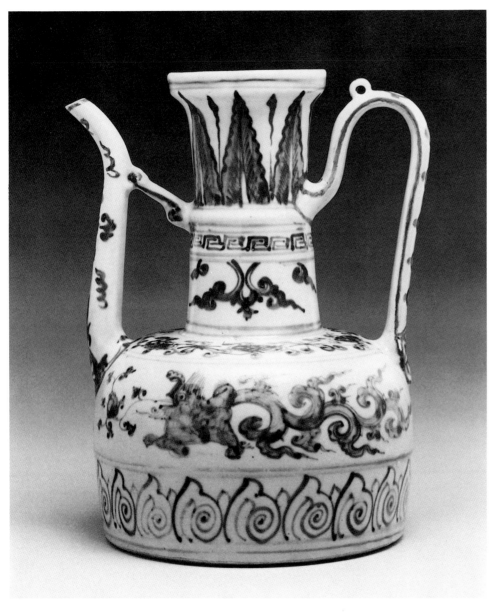

138. *Ewer*

138.
Ewer
China, Ming Dynasty,
second half of the 15th century
Blue-and-white ware
H. 25.4 cm (10 in.)
73.320

This squat ewer with a tall, wide neck and a flat, unglazed base has a slender handle and a spout, both of which have been restored. The decoration of the ewer, painted in both dark and pale blue, shows a row of stiff leaves on the neck, a key fret border and two fungus-shaped scrolls on the body, and a band of floral scrolls on the shoulder. Above a stylized petal border on the main body are two fantastic beasts having dragon-like heads with open jaws and protruding tongues, from which spring floral sprays centered by pearls. These creatures each have two front legs and two wings at the shoulders, their bodies extending into elaborate scrolling tails.

Such fabulous animals appear on a small number of blue-and-white porcelain pieces that have been assigned to various dates, ranging from the late fifteenth to the early sixteenth century. (See Lee 1949, no. 95; Jenyns 1953, pls. 64A and 64B; and Pope 1956, pl. 62, p. 110, and footnote 226. For a blue-and-white jar decorated with the same creatures and bearing the mark of the Hsüan-tê Period [1426-35], see Joseph 1971, no. 33. For the same ewer exhibited here, see Lion-Goldschmidt 1978, pl. 131.)

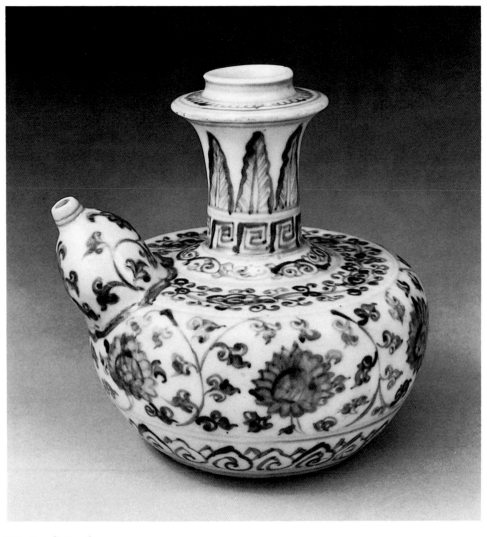

139.
Kendi Vessel
China, Ming Dynasty, late 15th century
Blue-and-white ware
H. 16.2 cm (6 3/8 in.)
72.712

This *kendi* drinking vessel has a squat body, a long neck with a projecting collar, and a bulbous spout. The slightly recessed, flat base is unglazed. Decorated in a warm purplish blue with lotus scrolls on the main body and spout, it has a band of trefoils above the base. On the shoulder are two scroll borders and around the neck is a row of stiff leaves above a band of key fret. The decoration of this vessel is closely related to that of a *kendi* in the Ardebil Collection in the Archaeological Museum in Teheran. (See Pope 1956, pl. 69 [top].)

139. Kendi Vessel

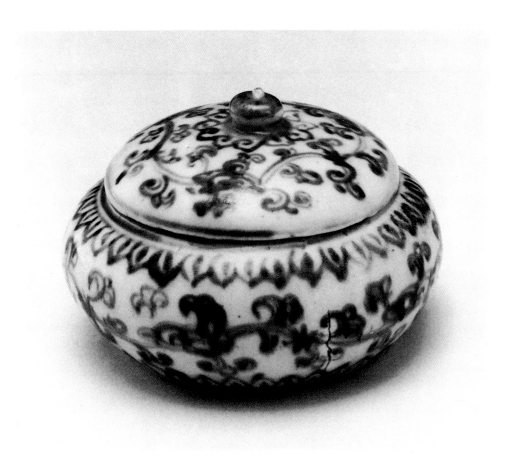

140.
Bowl with Cover
China, Ming Dynasty,
second half of the 15th century
Blue-and-white ware
Diam. 11.7 cm (4 5/8 in.)
73.354

This squat, bulbous bowl with a wide
mouth-rim is fitted with a domed cover
that has a central knob. The flat base is
unglazed. On the sides of the bowl, between
two petal borders, is a band of fungus-
shaped scrolls that is repeated on the cover.
The entire decoration is painted in a
warm purplish blue.

140. *Bowl with Cover*

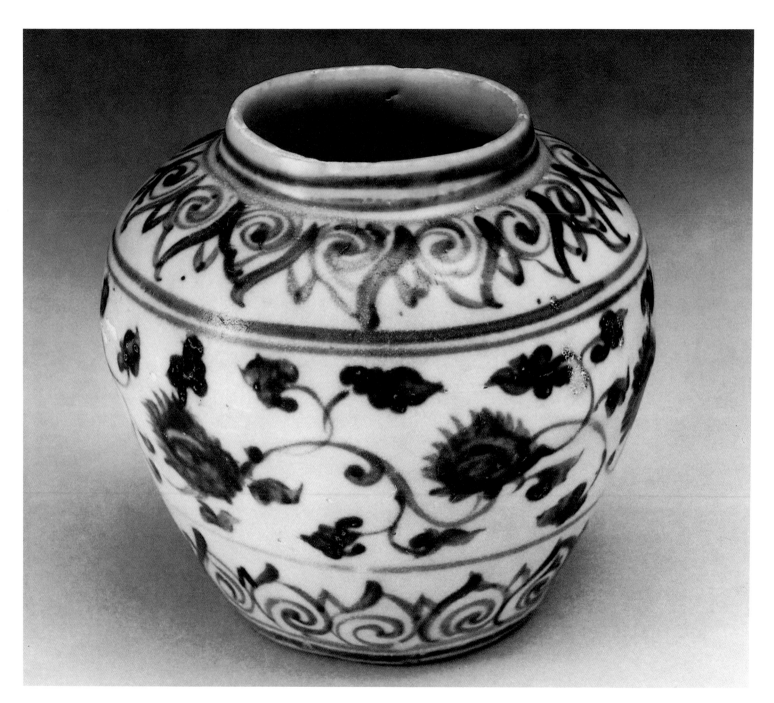

141. *Jar*

141.
Jar
China, Ming Dynasty,
second half of the 15th century
Blue-and-white ware
H. 10.8 cm (4 1/4 in.)
72.701

This ovoid jar has a low, wide mouth-
rim and a flat, unglazed base. It is decorated
in a warm purplish blue with a border
of pendant, stylized petals on the shoulder,
below which is a wide band of lotus
scrolls with large lobed leaves. Above the
base is a border of upright petals similar
to those on the shoulder.

142. *Jar*

142.
Jar
China, Ming Dynasty,
late 15th-early 16th century
Blue-and-white ware
H. 5.1 cm (2 in.)
Found on Samar Island, Philippines
72.719

This small, globular jar with a contracted mouth and a flat, unglazed base is decorated with stylized lotus scrolls painted in a warm blue. A scalloped border surrounds the mouth and a row of petals encircles the body just above the base.

143.
Jar
China, Ming Dynasty,
late 15th-early 16th century
Blue-and-white ware
H. 5.7 cm (2 1/4 in.)
72.718

This small, globular jar with a short neck and a flat, unglazed base is decorated with stylized lotus scrolls of the type seen in no. 142.

Not illustrated.

144.
Jar with Cover
China, Ming Dynasty,
late 15th–early 16th century
Blue-and-white ware
H. (with cover) 12.2 cm (5 in.)
73.353

This ovoid jar with a low neck and a
flat, unglazed base was molded in two hori-
zontal sections that have been luted
together. It is decorated in purplish blue
with a band of stylized lotus scrolls
above a panel containing sketchy motifs.
The domed cover has four broad petals
around the central knob. (For a similar jar,
see Aga-Oglu 1975, no. 140.)

144. *Jar with Cover*

145.
Jar
China, Ming Dynasty,
late 15th-early 16th century
Blue-and-white ware
H. 6.4 cm (2 1/2 in.)
73.356

This small jar has rounded sides, a short,
narrow neck, and a slightly recessed,
unglazed base. It is decorated in pale blue
with two floral branches on the sides
and a border of cloud-collar panels enclos-
ing tendril scrolls on the shoulders.

145. *Jar*

146.
Jar
China, Ming Dynasty,
late 15th-early 16th century
Blue-and-white ware
H. 6 cm (2 3/8 in.)
73.364

This small jar has rounded sides, a short,
narrow neck, and a flat, unglazed base.
It is decorated in pale blue with two sketchy
floral branches on the sides and a trefoil
border on the shoulder.

Not illustrated.

147.
Jar
China, Ming Dynasty,
late 15th-early 16th century
Blue-and-white ware
H. 5.7 cm (2 1/4 in.)
73.357

This small jar has a globular body,
a short, narrow neck, and a flat, unglazed
base. It is decorated in a purplish blue
with a scalloped border on the shoulder
and two floral branches on the sides.

Not illustrated.

148.
Jar
China, Ming Dynasty, late 16th century
Blue-and-white ware
H. 9.5 cm (4 3/4 in.)
Found on Samar Island, Philippines
72.721

This ovoid jar has a short, narrow neck
and a slightly recessed base. It is decorated
in a grayish pale blue with a border of
trefoils on the shoulder and birds on peach
branches on the sides.

Not illustrated.

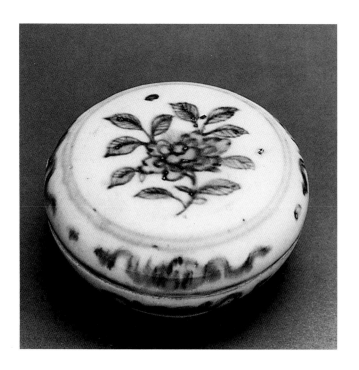

149.
Box with Cover
China, Ming Dynasty, 16th century
Blue-and-white ware
H. (with cover) 4.5 cm (1 3/4 in.),
Diam. 8.2 cm (3 1/4 in.)
72.698

This small, round box with a flattened
cover and a low foot-rim is entirely glazed,
except for the rims of the cover and
the box. It is decorated in dark blue with
a peony spray on the top of the cover
and with three symbolic emblems with
streamers on the sides of both the box
and the cover. Under the glaze of the base
are four Chinese characters in blue, with-
out encircling lines: *Hsüan Tĕ Nien Tsao*
("made in the reign period of Hsüan-tê"
[1426-35]). However, the box is in all
aspects typical of the Chia-ching Period
(1522-66), especially in the style and color
of its decoration.

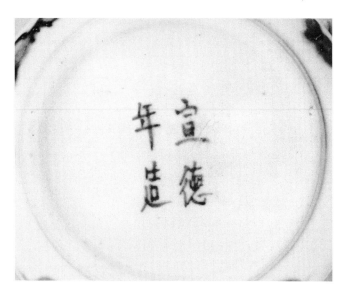

149. *Box with Cover*

150.
Box with Cover
China, Ming Dynasty, 16th century
Blue-and-white ware
H. (with cover) 4.5 cm (1 3/4 in.),
Diam. 7.6 cm (3 in.)
73.347

This small, round box has a domed cover
and a thin, low foot-rim. It is entirely
glazed, except for the rims of the cover and
the box. It is decorated in dark blue
with a duck swimming among lotus flowers
on the cover and two clusters of sea-
weed on the sides of the box. (For a similar
box decorated with a cormorant,
see Aga-Oglu 1972, no. 30.)

150. *Box with Cover*

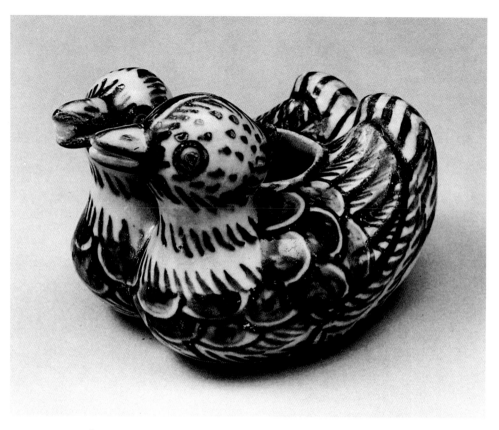

151.
Wine Vessel
China, Ming Dynasty,
probably early 16th century
Blue-and-white ware
H. 8 cm (3 1/8 in.)
72.702

This wine vessel is in the shape of a pair
of mandarin ducks. The drake's open
beak, holding a round object, forms the
spout. In the center of the ducks' backs
is a circular opening for filling the vessel.
The well-defined feathers of the ducks
are painted in a dark grayish blue. The flat
base is unglazed.

151. *Wine Vessel*

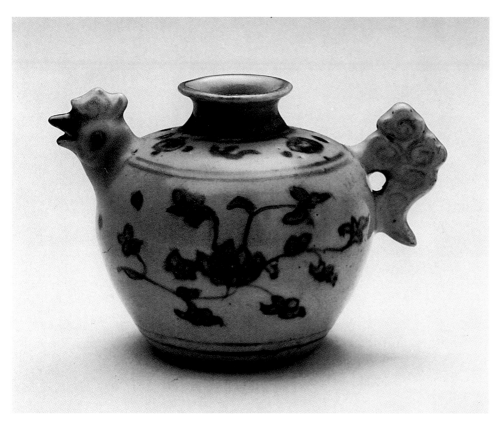

152. *Ewer*

152.
Ewer
China, Ming Dynasty, early 16th century
Blue-and-white ware
H. 7.7 cm (3 in.)
73.316

This ewer has rounded sides, a short, flaring neck, and a slightly recessed, unglazed base. The spout of the vessel is in the shape of a chicken head, while the handle is a stylized tail. The ewer is decorated in a pale grayish blue with two lotus sprays on the sides and symbolic motifs on the shoulder. (For two similarly shaped ewers, one blue-and-white ware and the other enameled, see Aga-Oglu 1975, nos. 145 and 153 [right].)

153. *Bowl*

153.
Bowl
China, Ming Dynasty,
first half of the 15th century
Blue-and-white ware
Diam. 14.9 cm (5 7/8 in.)
73.340

This finely potted, deep bowl has a flaring rim, a thin foot-rim, and a flat, glazed base. The decoration is skillfully painted in a warm purplish blue under a bluish white glaze. On the exterior are four large chrysanthemums connected with scrolling foliage. On the interior are four flower sprays around the sides, and in the center is a bunch of lotus flowers and water weeds tied with a band.

The central decoration in this bowl is a simplified version of a more elaborate composition of lotus flowers and other water plants tied with an undulating ribbon that appears in the centers of a large number of blue-and-white dishes which have been assigned to the early fifteenth century. (See Lee 1949, no. 39; Jenyns 1953, pl. 15A; Garner 1954, pl. 13; Pope 1956, pls. 30 and 31; and Wirgin 1964, no. 20. For a dish with a Hsüan-tê Period mark [1426-35], see Valenstein 1970, no.10.)

154.
Bowl
China, Ming Dynasty, early 16th century
Blue-and-white ware
Diam. 13 cm (5 1/8 in.)
72.710

This deep bowl with a straight rim and a thin foot-rim is decorated in pale blue, showing on the exterior a border of waves at the rim and a row of floral sprays on the sides. In the interior is a central medallion composed of four sketchy trefoils.

Not illustrated.

155.
Bowl
China, Ming Dynasty, 16th century
Blue-and-white ware
Diam. 12.4 cm (4 7/8 in.)
72.711

This deep bowl has a flaring rim and a thin foot-rim. It has a grayish blue, sketchy decoration of a fruit branch in the center interior and two sprays of tall blades of grass or weeds on the exterior.

Not illustrated.

156. *Bowl*

156.
Bowl
China, Ming Dynasty, late 16th century
Blue-and-white ware
Diam. 21.3 cm (8 3/8 in.)
73.349

This bowl with rounded sides, a straight
rim, and a thin foot-rim is decorated
in a dark purplish blue. The central medal-
lion in the interior encloses a large figure
of a prancing elephant among clouds,
reserved in white on a blue ground. On the
exterior, three leaping dragons, also
reserved in white, are separated by three
flaming pearls and rocks and waves
which have been rendered in blue. Around
the foot is a scroll border, and under
the glaze of the base is a square seal in blue.
The bowl is in every respect typical of
the Wan-li Period (1573-1619).

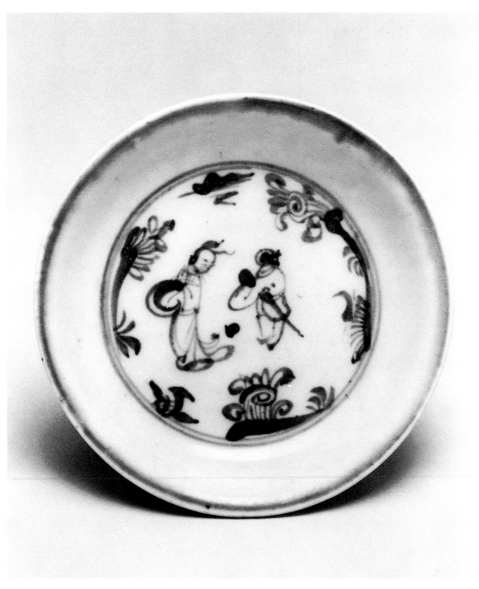

157. *Dish*

157.
Dish
China, Ming Dynasty, late 15th century
Blue-and-white ware
Diam. 13.7 cm (5 3/8 in.)
72.703

This shallow dish with a flaring rim
and a low foot-rim is decorated in a warm
purplish blue and shows children play-
ing among shrubs in the center of the inte-
rior. On the exterior is a band of lotus
scrolls. (For similar dishes, see Aga-Oglu
1972, nos. 25 and 26.)

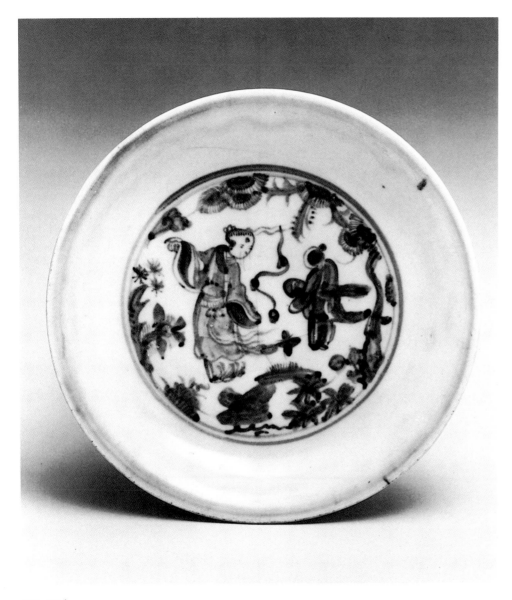

158.
Dish
China, Ming Dynasty, late 15th century
Blue-and-white ware
Diam. 21 cm (8 1/4 in.)
Found on Palawan Island, Philippines
72.707

This shallow dish has a flaring rim and a low foot-rim. The decoration in the center, painted in a warm purplish blue, shows two figures in a landscape with a pine tree and shrubs. On the exterior is a band of peony scrolls.

158. *Dish*

159. *Dish*

159.
Dish
China, Ming Dynasty, 16th century
Blue-and-white ware
Diam. 19.2 cm (7 3/4 in.)
72.717

This shallow dish with a flattened rim and a low foot-rim is decorated in a purplish blue with a phoenix standing on one foot among plants and clouds. Along the rim there is a border of symbolic emblems with streamers that alternate with fruits. On the exterior are two floral sprays. The decoration of this dish, especially the symbolic motifs with streamers, is in the style of the Chia-ching Period (1522-66). A similar dish is in the Philippine Collection of the Museum of Anthropology, University of Michigan. (See Aga-Oglu 1963, fig. 13 [left].)

160.
Dish
China, Ming Dynasty, 16th century
Swatow-type blue-and-white ware
Diam 28.2 cm (11 1/4 in.)
73.351

This large, shallow dish with a flattened rim has a low foot-rim with sand accretions and a partially glazed base. These are characteristic features of this type of coarse export porcelain. The dish is decorated in a grayish blue with a deer in a landscape in the center and a border of galloping horses among cloud and wave motifs on the rim. The exterior is plain.

160. *Dish*

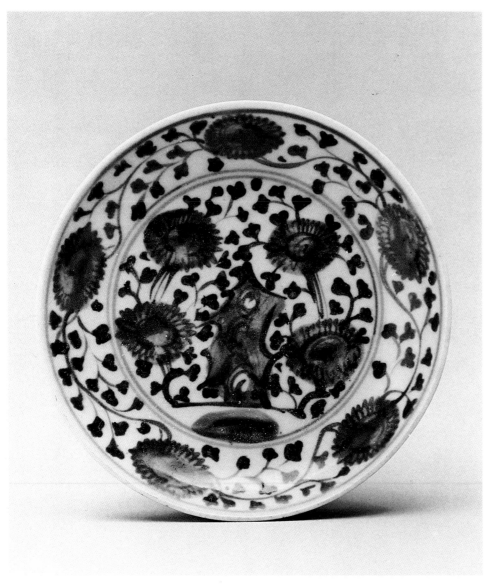

162. *Dish*

161.
Dish
China, Ming Dynasty, 16th century
Swatow-type blue-and-white ware
Diam. 28 cm (11 in.)
73.352

This large dish has a straight rim,
a low foot-rim with sand accretions, and
a partially glazed base. It is decorated
on the interior only. Rendered in dark blue
are deer in a landscape in the center
and branches of pine, bamboo, and fruit
trees on the sides.

Not illustrated.

162.
Dish
China, Ming Dynasty, 16th century
Blue-and-white ware
Diam. 20.3 cm (8 in.)
72.706

This shallow dish with a straight rim and
a low foot-rim is decorated in dark
blue. In the center of the interior is a rock
amid chrysanthemum scrolls with a
band of similar scrolls on the sides and the
exterior. (For a similar dish, see Aga-Oglu
1972, no. 35 [left].)

163.
Dish
China, Ming Dynasty, 16th century
Blue-and-white ware
Diam. 20 cm (7 7/8 in.)
72.705

This shallow dish with a flattened,
foliated rim and a low foot-rim is decorated
in grayish blue with a border of cross-
hatching at the rim and a *ch'i-lin* (fantastic
animal) in the center. On the exterior are
sketchy floral scrolls. (For similar dishes,
see Aga-Oglu 1963, fig. 7 [left]; Aga-Oglu
1972, no. 34 [left].)

Not illustrated.

164.
Dish
China, Ming Dynasty, late 16th century
Blue-and-white ware
Diam. 18.7 cm (7 3/8 in.)
72.713

This shallow dish with flaring sides and a
low foot-rim has a very sketchy grayish
blue decoration of a phoenix in the center
of the interior and three symbolic motifs
with streamers on the sides.

Not illustrated.

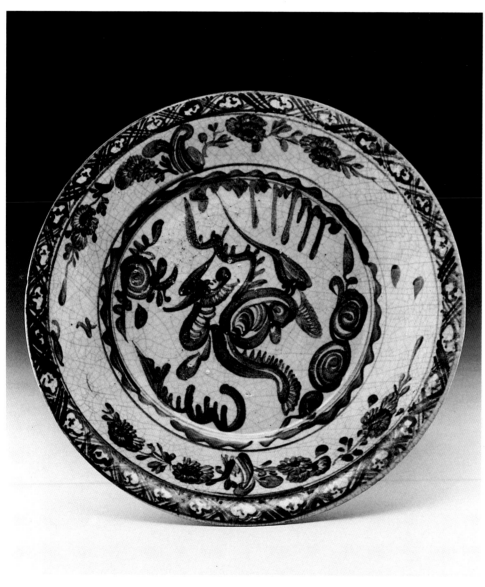

165. *Dish*

165.
Dish
China, Ming Dynasty, 16th century
Swatow-type blue-and-white ware
Diam. 40 cm (15 3/4 in.)
72.720

This large dish has a flattened rim,
a low foot-rim, and a glazed base with sand
accretions near the foot. It has a freely
executed bold decoration in grayish blue,
showing in the center a *ch'i-lin* among
plant and wave motifs. Around the rim is a
border of crosshatching, and on the cav-
etto are two floral sprays that are repeated
on the exterior. (For a similar dish in
the Princessehof Museum in Leeuwarden,
see Ottema 1946, fig. 162.)

166.
Dish
China, Ming Dynasty, late 16th century
Swatow-type blue-and-white ware
Diam. 38 cm (15 in.)
Found on Mindoro Island, Philippines
72.723

This large dish has a flattened rim, a low
foot-rim, and an unglazed base. It has a
very coarse porcelain body and a grayish
blue, sketchy decoration of two dragons
and a pearl in the center of the interior,
panels enclosing fruit and flowers on the
cavetto, and a border of floral designs on
the rim.

Not illustrated.

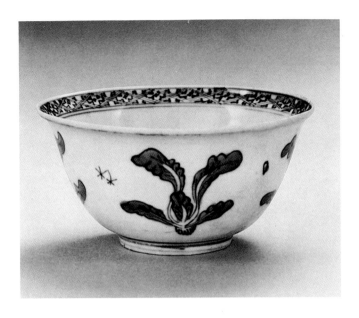

167 and 168.
Bowls
China, late Ming Dynasty
Blue-and-white ware
Diam. (each) 12 cm (4 3/4 in.)
72.714, 72.715

These deep bowls, one of which is illustrated, both have flaring rims and thin foot-rims. The thinly potted translucent porcelain bodies are decorated in a rich sapphire blue, showing on the interior a diamond-patterned border at the rim and a large figure of a toad in the center. On the exteriors are four large plant motifs resembling Chinese cabbages. Under the glaze of the bases are four Chinese characters in blue: *fu kuei chia ch'i.* Taken all together, they may be translated as "precious vessel."

No. 168 not illustrated.

167. Bowl

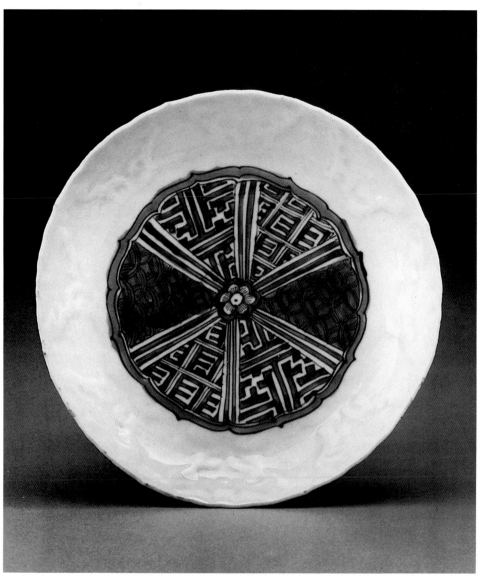

169. *Dish*

169 and 170.
Dishes
China, Ch'ing Dynasty, 18th century
Blue-and-white ware
Diam. (each) 20.3 cm (8 in.)
73.359, 73.360

These shallow dishes, one of which
is illustrated, have foliated rims, low foot-
rims, and thinly potted porcelain bod-
ies covered with a glossy, aqua-toned glaze.
The decoration of a central medallion
in blue is composed of pie-shaped panels
filled in with a diaper pattern. The sides,
both interior and exterior, have an under-
glaze molded decoration of foliate
panels containing flowers. The panels are
separated from each other by pome-
granates with the seeds exposed. Around
the foot-rims are petal borders in blue.

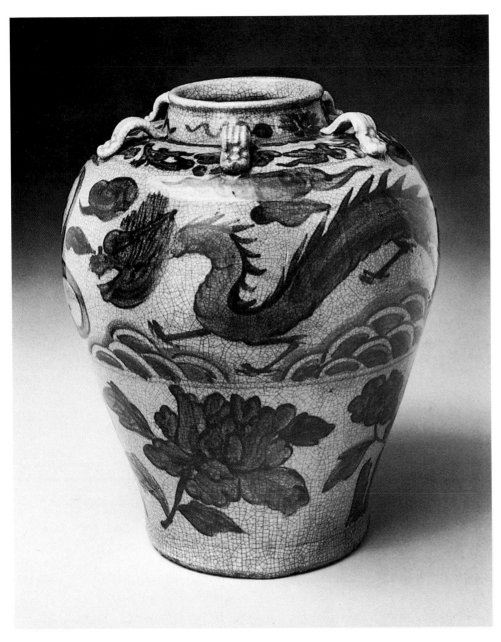

171.
Jar
China, Ming Dynasty, 16th century
Swatow-type blue-and-white ware
H. 35 cm (13 3/4 in.)
74.240

This *kuan* jar has a low neck, five loop handles on the shoulder, and a recessed base with sand adhering to the thin glaze. The bold decoration is painted freely in grayish blue. On the upper portion of the main body are two serpentine dragons chasing a flaming pearl, below which large peony flowers alternate with rocks. On the shoulder is a border of floral scrolls. An almost identical jar is in the Topkapu Sarayi Müzesi in Istanbul. (See Aga-Oglu 1955, fig. 26.)

171. *Jar*

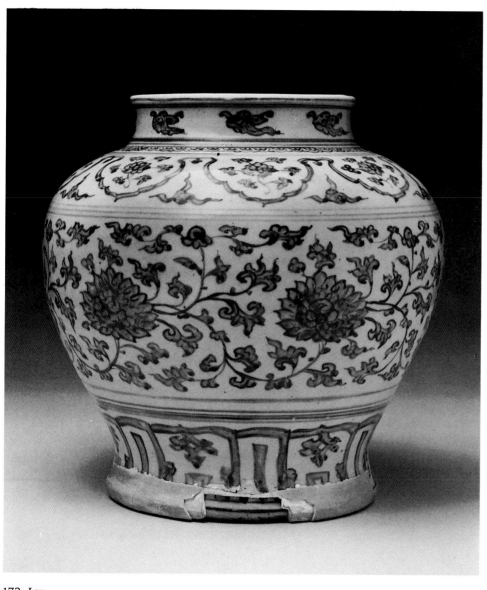

172. *Jar*

172.
Jar
China, Ming Dynasty, early 16th century
Blue-and-white ware
H. 31 cm (12 1/4 in.)
73.319

This large *kuan* jar is decorated in pale blue with a cloud border around the low neck and cloud-collar panels enclosing floral sprays on the shoulder. A wide band of lotus scrolls encircles the main body and stylized petal panels surround the base.

Half of the base of this jar has been restored with white plaster, a portion of which has broken off to reveal a small section of a base that seems to be from another vessel, since the color of its decoration does not match that of the jar.

173.
Jar and Cover
China, late Ming Dynasty
Blue-and-white ware
H. (with cover) 27.6 cm (10 7/8 in.)
73.307

This jar has rounded sides, a sloping
shoulder, and a high spreading foot which
has been restored. It is decorated
with diaper-patterned bands and floral
motifs on the neck and shoulder,
four medallions containing birds on rocks
on the main body, and a border of stiff
panels around the foot. On the shoulder
are four handles in the shape of lion-
masks. The decoration is in underglaze
blue with some details rendered in
overglaze turquoise and red enamels that
seem to have been added later and
have mostly worn off. The cover, topped
by the figure of a lion, does not seem
to belong to this jar.

Not illustrated.

174.
Jar
China, Ming Dynasty, 16th century
Enameled porcelain
H. 16.2 cm (6 3/8 in.)
72.695

This jar has rounded sides, a low neck,
and a flat, unglazed base. It is decorated
with bands of petals on the shoulder,
floral scrolls on the sides, and stiff petals
above the base that have been rendered
in red and green enamels and which have,
for the most part, worn off.

Not illustrated.

175.
Dish
China, Ming Dynasty, 16th century
Enameled porcelain
Diam. 23.8 cm (9 3/8 in.)
72.694

This shallow dish with a straight rim
and a low foot-rim is decorated on the inte-
rior and exterior with floral scrolls
in red enamel which has worn off.

Not illustrated.

176.
Ewer
China, probably 19th century
Porcelain
H. 24.4 cm (10 5/8 in.)
73.328

This porcelain ewer, molded in the shape
of a dragon riding on waves, is washed over
with glazes of green, yellow, and brown.

Not illustrated.

177.
Ewer
China, probably 19th century
Porcelain
H. 19.7 cm (7 3/4 in.)
72.722

This ewer, molded in the shape of a
prawn riding on waves, is washed over with
glazes of green, yellow, and brown.

Not illustrated.

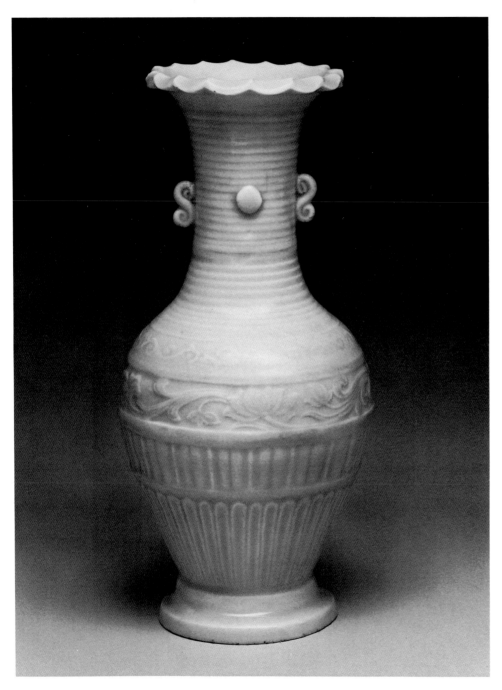

178.
Vase
China, probably early Ch'ing Dynasty,
17th century
Porcelain
H. 25.5 cm (10 in.)
73.361

This ovoid vase has a tall neck with a
flaring, scalloped rim and a high, spread-
ing foot-rim. The neck has concentric
rings, and applied to its middle section are
two small S-shaped ears and two studs.
Around the shoulder and the upper por-
tion of the sides are two narrow bor-
ders of floral designs molded in low relief,
below which are narrow and wide
bands of vertical fluting. The vase is cov-
ered with a glossy, aqua-toned glaze,
except for the edges of the foot-rim and
the base.

178. *Vase*

179.
Ewer
China, Yüan Dynasty
Porcelain
H. 18.8 cm (7 3/8 in.)
72.591

This ovoid ewer with a low mouth-rim
and a sturdy foot-rim has a curving spout
and a grooved handle. Two small loops
are attached at each side of the mouth-rim.
The porcelain body is covered with a
pale aqua-toned glaze that stops above the
foot-rim.

Not illustrated.

180.
Kendi Vessel
China, late Ming Dynasty
Brown-glazed porcelain
H. 11.8 cm (4 5/8 in.)
73.335

This crudely made, bulbous *kendi*
drinking vessel with ribbed sides has a tall,
flanged neck, a low foot-rim, and a
bulbous, ribbed spout. It is entirely cov-
ered with a chocolate brown glaze.
The decoration, rendered in lines and dots
in white slip, consists of blossoming
branches on the shoulder and grass motifs
on the neck.

Not illustrated.

181.
Bowl
China, late Ming Dynasty
Porcelain
Diam. 17.1 cm (6 3/4 in.)
72.726

This heavily potted bowl with a straight
rim and a rather high foot-rim has on the
interior a molded decoration of men
playing chess. The porcelain body is cov-
ered with a glossy, aqua-tinged glaze,
except for the base.

Not illustrated.

182.
Jar
China, late Ming Dynasty
Porcelain
H. 19 cm (7 1/2 in.)
73.304

This jar has a rounded body, a short
neck, and a flat base and is covered with
a cobalt blue glaze.

Not illustrated.

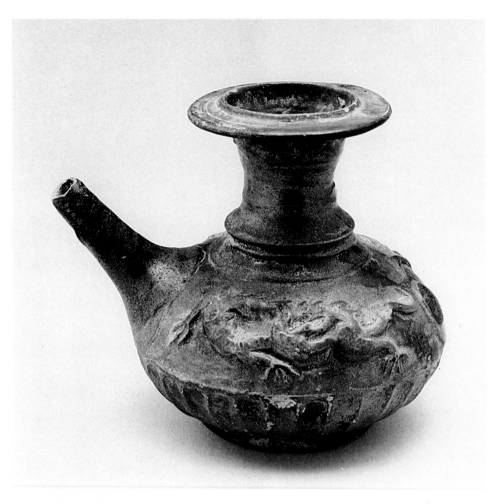

183.
Kendi Vessel
China, Yüan Dynasty
Lead-glazed earthenware
H. 10.8 cm (4 1/4 in.)
72.675

This *kendi* drinking vessel is squat and bulbous with a flaring neck, a slender spout, and a flat base. The main body was molded in two horizontal sections that have been joined at the middle. It is decorated in molded relief with two dragons chasing a flaming pearl, below which is a band of fluting. It is covered with a green lead glaze, except for the base. (For a similar vessel, see Aga-Oglu 1975, no. 171.)

183. *Kendi Vessel*

184.
Kendi Vessel
China, Ming Dynasty
Lead-glazed ware
H. 19.1 cm (7 1/2 in.)
73.318

This bulbous *kendi* drinking vessel
has a slender neck, a bulbous spout, and
a sturdy foot-rim. It is decorated in
low relief with floral scrolls on the shoulder
and spout and dragons and pearl motifs
around the main body. A green lead glaze
covers the vessel, including the base.

Not illustrated.

185.
Jar
China, Yüan Dynasty
Lead-glazed earthenware
H. 6.4 cm (2 1/2 in.)
72.572

This small, globular jar has a short neck
and a flat, unglazed base. It is decorated in
molded relief with two dragons and a
pearl and is covered with green and red-
dish brown lead glazes.

Not illustrated.

186.
Tea Pot
China, Yüan Dynasty
Lead-glazed earthenware
H. 6.4 cm (2 1/2 in.)
72.680

This tea pot with fluted sides, a short neck,
and a low foot-rim has a rounded han-
dle and a straight spout. It is decorated in
low relief with a petal border on the
shoulder and is covered with a green lead
glaze which stops unevenly above the foot.

Not illustrated.

187.
Ewer
China, Yüan Dynasty
Lead-glazed earthenware
H. 6 cm. (2 3/8 in.)
72.571

This bulbous ewer has a short, bulging
neck, a small handle, a slender spout, and
a flat, roughly finished base. The earth-
enware body is covered with a streaked,
green lead glaze. (For similar ewers,
see Aga-Oglu 1975, nos. 172 and 173.)

Not illustrated.

188.
Ewer
China, Yüan Dynasty
Lead-glazed earthenware
H. 7.6 cm (3 in.)
72.567

This ewer with a collapsed handle
is of the same type described in no. 187,
except that it has a reddish brown
glaze which stops unevenly below the mid-
dle part.

Not illustrated.

189.
Water Dropper
China, Yüan or early Ming Dynasty
Lead-glazed earthenware
L. 8.5 cm (3 3/8 in.)
72.570

This toad-shaped water dropper is covered
with a green lead glaze.

Not illustrated.

190.
Bowl
China, probably Yüan Dynasty
Lead-glazed ware
Diam 9.2 cm (3 5/8 in.)
72.576

This bowl has a flaring rim, a sturdy foot-
rim, and a convex, unglazed base. The
grayish white body is covered with a mot-
tled green lead glaze. In the center of
the interior is a floral medallion in high
relief covered with a reddish glaze.

Not illustrated.

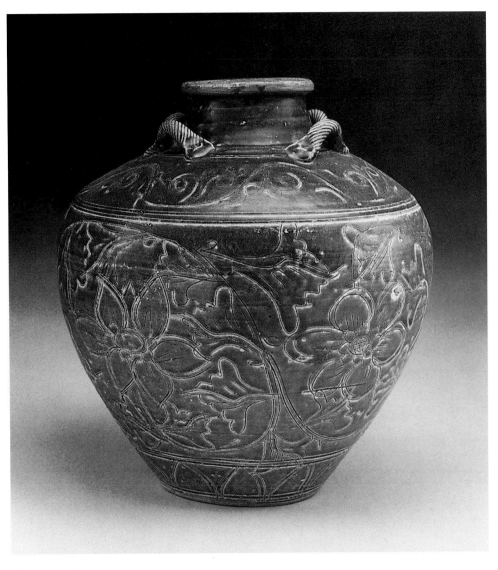

191. *Storage Jar*

191.
Storage Jar
China, Yüan Dynasty
Stoneware
H. 35 cm (13 3/4 in.)
72.39

This ovoid storage jar has a sloping shoulder, a short neck, and a concave, unglazed base. On the shoulder are four small, horizontal handles. The jar is decorated with bold, incised designs of a scroll border on the shoulder, floral scrolls on the sides, and a band of petals above the base. The stoneware body is covered with a brown glaze.

192.
Storage Jar
China, late Ming Dynasty
Stoneware
H. 58.5 cm (23 in.)
74.239

This ovoid storage jar with a short neck and a flat base has six lion-head handles on the shoulder and six dragons applied in high relief around the sides. It is covered with a yellowish tan glaze which stops at the lower portion of the sides.

Not illustrated.

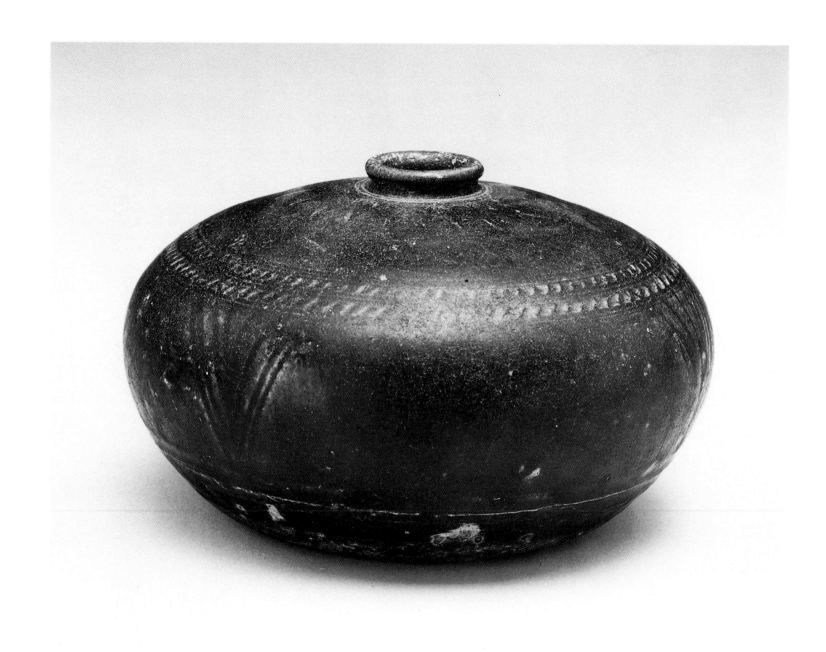

194. *Oil Jar*

193.
Storage Jar
China, late Ming Dynasty
Stoneware
H. 92.3 cm (36 3/8 in.)
73.365

This ovoid storage jar with a short neck
and a flat base has eight animal-head
handles on the shoulder. It is decorated in
relief with two dragons and cloud and
pearl motifs, and is covered with a streaked,
blue glaze which stops above the base.
The dragons are coated with a reddish
brown glaze.

Not illustrated.

194.
Oil Jar
Cambodia, Khmer Period,
11th-13th century
Stoneware
H. 10 cm (4 in.)
73.311

This squat, bulbous jar has a short, narrow
neck and a flat base. Its decoration
consists of an incised petal border on the
shoulder and four sprays of grooves on
the sides. The stoneware body is covered
with a dark brown glaze, except for
the base. (For a related jar, see Frasché,
1976, no. 8.)

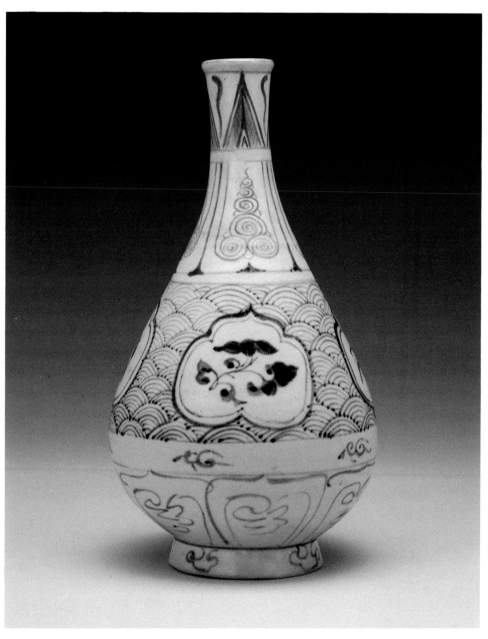

195. *Bottle*

195.
Bottle
Vietnam, 15th century
Blue-and-white ware
H. 26 cm (10 1/4 in.)
73.317

This pear-shaped bottle has a slender neck, a low foot-rim, and a flat base washed with brown slip. It is decorated in dark and light blue with borders of stiff leaves and pendant lotus panels around the neck. On the main body is a band of foliated medallions with floral sprays, set on a ground of waves, below which is a border of lotus panels.

Vietnamese blue-and-white and other porcelain wares have two characteristic features. The first is the use of white slip over the porcelain body, whether decorated or plain, and the second is a wash of brown slip on the unglazed base.

The wares now called Vietnamese were previously known as Annamese, after the name Annam, or "Pacified South," given by the Chinese in the early T'ang period to this area, which had been controlled by them since the Han Dynasty. (See Frasché 1976, pp. 16 and 95.)

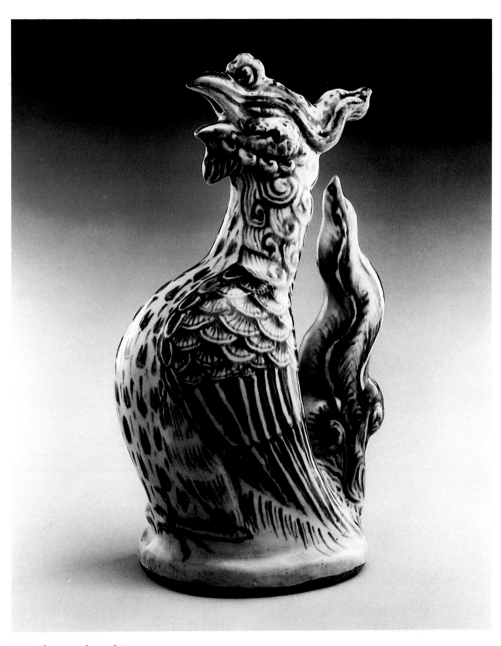

196.
Phoenix-shaped Ewer
Vietnam, 16th century
Blue-and-white ware
H. 28.9 cm (11 3/8 in.)
73.325

This ewer is in the shape of a phoenix,
the tail of which forms the handle, and the
beak the spout. An opening for filling
the vessel is located at the top of the head.
The feathers and other features are
carefully rendered in both dark and pale
blue. The flat base is unglazed.

196. *Phoenix-shaped Ewer*

197. *Tea Pot*

197.
Tea Pot
Vietnam, 15th-16th century
Blue-and-white ware
H. 11.5 cm (4 1/2 in.)
73.303

This squat, bulbous tea pot with a short
spout and a high loop handle is decorated
in dark blue with peony scrolls above
a border of petals. The cover, with a central
loop, has two leaves painted in blue.
The flat, unglazed base shows thin streaks
of brown wash.

198. *Jar*

198.
Jar
Vietnam, 15th century
Blue-and-white ware
H. 8.9 cm (3 1/2 in.)
72.733

This jar with rounded sides, a short neck, and a low foot-rim has four horizontal handles on the shoulder. The dark grayish blue decoration consists of a border of petals on the shoulder and a band of floral scrolls on the sides. The flat base is unglazed. (For a related jar, see Aga-Oglu 1975, no. 80 [right].)

199.
Jar
Vietnam, 15th-16th century
Blue-and-white ware
H. 10.5 cm (4 1/8 in.)
73.344

This rounded jar has a short, flaring neck at the rim and a recessed, unglazed base. It is decorated in grayish blue with an all-over pattern of floral scrolls.

Not illustrated.

201. *Box*

200.
Dish
Vietnam, 15th century
Blue-and-white ware
Diam. 14.5 cm (5 3/4 in.)
73.341

This dish has a straight rim, a low foot-rim, and a flat base washed with brown slip. It is decorated in dark grayish blue with a floral spray in the center, a scroll border at the rim, and lotus panels on the exterior.

Not illustrated.

201.
Box
Vietnam, 15th century
Blue-and-white ware
H. (with cover) 5 cm (2 in.)
73.350

This hexagonal box with cover is decorated in grayish blue with alternating panels of foliage and diaper pattern on the sides. The cover bears a large rosette in the center. The recessed base is unglazed. (For a related box, see Aga-Oglu 1975, no. 181 [left].)

202.
Jar
Vietnam, 15th century
Blue-and-white ware
H. 7.3 cm (2 7/8 in.)
72.732

This squat, bulbous jar has a thickened
mouth-rim and a flat base washed
with brown slip. The decoration, in pale
grayish blue, consists of a chrysan-
themum scroll on the shoulder and a band
of lotus panels on the sides.

Not illustrated.

203.
Box
Vietnam, 16th century
Porcelain
H. (with cover) 7.6 cm (3 in.)
73.342

This covered box with rounded sides
has a low foot-rim and a flat, unglazed base.
The sides of the box and the cover have
alternating panels of grass motifs and a pat-
tern of crosshatching in red enamel
that has almost completely worn off. The
top of the cover has a sketchy design
in pale grayish blue.

Not illustrated.

204.
Jar
Vietnam, perhaps 16th century
Blue-and-white ware
H. 16.2 cm (6 3/8 in.)
73.322

This jar, with a bulging shoulder
and sharply tapered sides, has a flat base
washed with brown slip. The wide
mouth-rim, which has been glued to the
upper portion of this jar, does not
belong to it. Its sides are decorated in pale
blue with a band of lotus and peony
scrolls above a border of lotus panels.

Not illustrated.

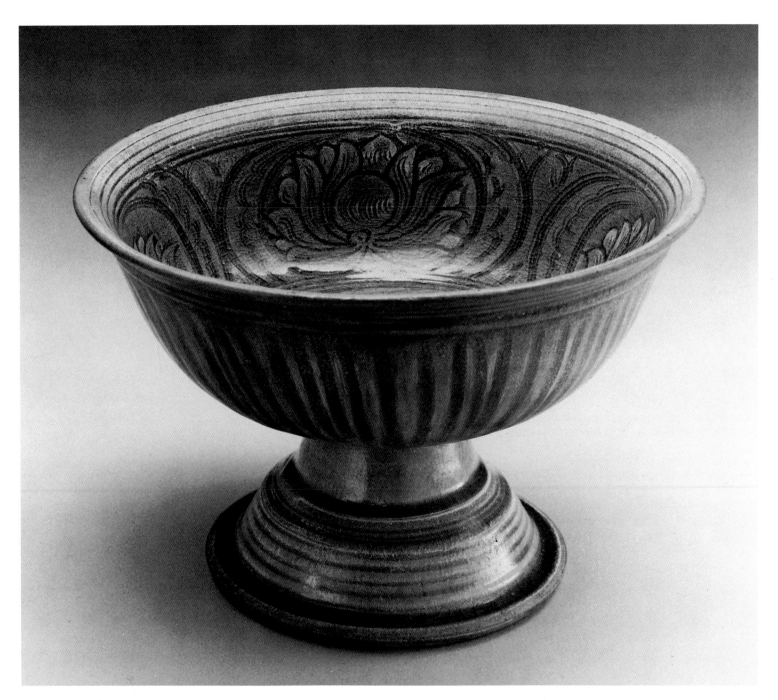

206. Stem Bowl

205.
Water Dropper
Vietnam, date uncertain
Stoneware
H. 5.7 cm (2 1/4 in.)
73.343

This water dropper in the shape of a crouching rabbit has sketchy markings in pale blue on its back.

Not illustrated.

206.
Stem Bowl
Thailand (Sawankhalok),
14th-mid-15th century
Celadon ware
H. 17 cm (6 5/8 in.)
73.308

This deep bowl with a flaring rim has a high, spreading, hollow foot. The exterior of the bowl is fluted and the foot has concentric rings. On the interior of the bowl is an incised decoration of a lotus flower surrounded by four medallions, each enclosing another lotus. The gray stoneware body is covered with a grayish green glaze, except for the inner side of the foot which shows a reddish paste. A portion of the side of the bowl has been restored. (For a similar stem bowl, see Locsin 1967, pl. 172.) The decoration on the interior of this bowl is very similar to that of two Sawankhalok celadon dishes. (See Frasché 1976, no. 21; and de Flines, 1975, pls. 80 and 81.)

207. *Dish*

207.
Dish
Thailand (Sawankhalok),
14th-mid-15th century
Celadon ware
Diam. 30.5 cm (12 in.)
73.315

This deep dish has a flattened rim with
an upturned edge and a low foot-rim. It has
an incised decoration of a band of waves
on the cavetto and a stiff rosette in the cen-
ter. The exterior is fluted. The unglazed
base, burned reddish buff in firing, shows
in the center a black circular mark left
by the kiln support, a characteristic feature
of Sawankhalok celadon ware. (For similar
dishes, see Aga-Oglu 1972, no. 77.)

208.
Bowl
Thailand (Sawankhalok),
14th-mid-15th century
Celadon ware
Diam. 14 cm (5 1/2 in.)
73.334

This deep bowl with a straight rim
and a low foot-rim is fluted on the exterior.
The gray stoneware body is covered
with a grayish green glaze which stops
unevenly above the foot-rim.

Not illustrated.

209. *Jar*

209.
Jar
Thailand (Sawankhalok),
14th-mid-15th century
Celadon ware
H. 15.3 cm (6 in.)
73.362

This globular jar, used for oil or wine, has two loop handles at the narrow neck and a low foot-rim. On the shoulder is a band of concentric rings. The gray stoneware body is covered with a grayish green glaze that stops above the foot. The exposed paste of the base, burned brick red in firing, shows in the center the characteristic circular mark found in Sawankhalok celadon ware.

210.
Jar
Thailand (Sawankhalok),
14th-mid-15th century
Celadon ware
H. 16.5 cm (6 1/2 in.)
Found on Samar Island, Philippines
72.730

This globular jar is similar to no. 209, except that it is covered with an olive brown glaze that has partially peeled away.

Not illustrated.

211. *Jar*

211.
Jar
Thailand (Sawankhalok),
probably first half of the 15th century
Stoneware
H. 19 cm (7 1/2 in.)
73.323

This ovoid jar has a short neck with two loop handles on the shoulder and a slightly recessed, unglazed base, burned reddish brown in firing, in the center of which is a circular mark. The gray stoneware body is decorated with incised designs of scrolling foliage on the shoulder, below which are four panels, three containing floral sprays and the fourth depicting a large bird holding a branch in its beak. The designs are coated with white slip under a transparent glaze, while the surrounding area is covered with a thin, olive green glaze.

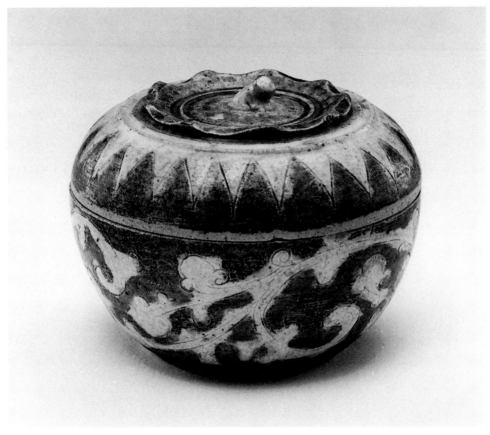

212. *Box*

212.
Box
Thailand (Sawankhalok),
probably first half of the 15th century
Porcelaneous stoneware
H. 10.8 cm (4 1/4 in.)
73.314

This box has rounded sides, a low foot-rim, and a flat, unglazed base showing a circular mark. The incised decoration consists of a band of scrolling foliage on the sides of the box and a border of stiff petals on the cover, in the center of which is a stem in molded relief. The designs are covered with a grayish aqua glaze, while the surrounding areas are coated with a brown glaze. (For related boxes, see Locsin 1967, pl. 185; de Flines 1975, pl. 82; Cheng 1972, pl. 27, no. 106; Frasché 1976, nos. 16-18; and Aga-Oglu 1975, no. 195.)

213.
Box
Thailand (Sawankhalok),
probably first half of the 15th century
Porcelaneous stoneware
H. 10 cm (4 in.)
73.310

This box with rounded sides and a flat
cover has a low foot-rim and a flat, unglazed
base showing a circular mark. Decorated
with bands of foliage scrolls and stiff petals
on the sides and around the central
knob of the cover, the box is coated with
a brown glaze.

Not illustrated.

214.
Box
Thailand (Sawankhalok), 15th century
Stoneware
H. 5.4 cm (2 1/8 in.)
72.731

This squat, globular box has a flat,
unglazed base and a knob in the center
of the cover. The gray stoneware body
is coated with white slip and is decorated
with panels of sketchy foliage painted
in brown under a thin glaze.

Not illustrated.

215.
Box
Thailand (Sawankhalok), 15th century
Stoneware
H. 5.4 cm (2 1/8 in.)
73.345

This box with rounded sides and a flat,
unglazed base is coated with white slip and
decorated with sketchy designs of fol-
iage painted in brown under a thin glaze.
The cover, which does not belong to
this box, is coated with white slip and dec-
orated in brown with scrolling foliage
that differs in design from that of the box.

Not illustrated.

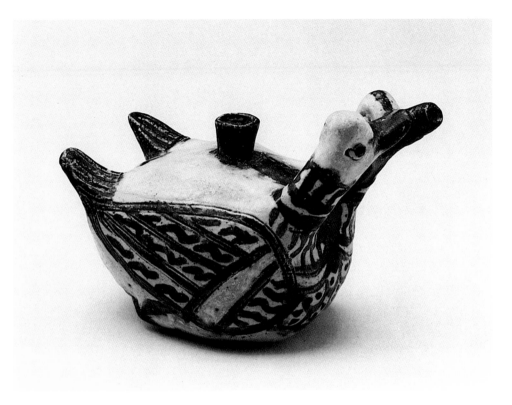

216.
Water Pot
Thailand (Sawankhalok), 15th century
Porcelaneous stoneware
H. 8 cm (3 1/8 in.)
73.333

This water pot is in the form of a pair of ducks. The beak of one forms the spout, and in the center of the ducks' backs is a tubular opening for filling the vessel. The stylized feathers of the ducks are painted in brown and the rest of the vessel is covered with a bluish gray glaze, except for the flat base. (For a similar vessel, see Aga-Oglu 1975, no. 198.)

216. *Water Pot*

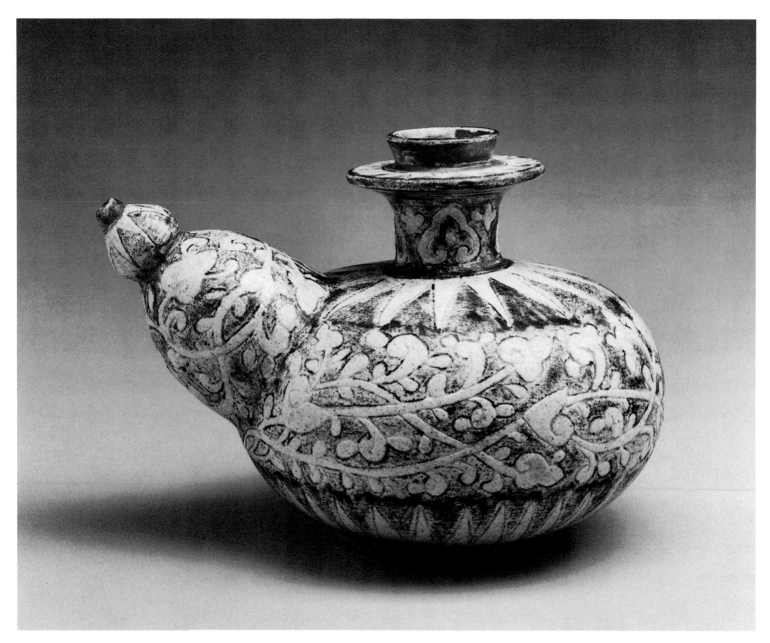

217. *Kendi Vessel*

217.
Kendi Vessel
Thailand (Sawankhalok), 15th century
Porcelaneous stoneware
H. 16.5 cm (6 1/2 in.)
73.302

This squat, globular *kendi* drinking
vessel with a short, flanged neck and a bul-
bous spout, has a low foot-rim and a
flat, unglazed base. The incised decoration
consists of a continuous foliage scroll
on the main body and spout, and borders
of stiff petals on the shoulder and
flange and above the base. The designs are
coated with white slip under a trans-
parent glaze, while the surrounding areas
are covered with a thin, brown glaze.

218.
Vase
Thailand (Sawankhalok),
probably 15th century
Porcelaneous stoneware
H. 22.2 cm (8 3/4 in.)
73.330

This globular vase has a wide, trumpet-
shaped neck and a low platform base.
It is decorated on the shoulder with bands
of incised wave motifs and is covered
with a streaked, brown glaze that stops at
the lower portion of the sides.

Not illustrated.

219.
Vase
Thailand (Sawankhalok),
probably 15th century
Porcelaneous stoneware
H. 17.8 cm (7 in.)
73.329

This globular vase has a low foot-rim
and a short neck that swells into a cup-
shaped mouth. It is decorated on the
shoulder with concentric rings and is cov-
ered with a dark brown glaze that
stops at the lower portion of the sides.

Not illustrated.

220.
Dish
Thailand, modern reproduction
Stoneware
Diam. 33.5 cm (13 1/4 in.)
73.363

This shallow dish has a flattened, scalloped rim and a low foot-rim with a neatly cut, flat edge. The gray, fine-grained stoneware body is coated with white slip and is decorated in brown with two fish on the cavetto and a large fish-shaped motif in the center, all under a transparent glaze. The rim is washed with a red underglaze pigment, and the unglazed base has a red semicircle in the center. This dish is a modern reproduction of the well-known Sukhothai dishes with fish designs of the 13th-14th centuries.

Not illustrated.

221.
Elephant
Thailand, perhaps 19th century
Stoneware
H. 36.6 cm (14 3/8 in.)
72.38

This figure of an elephant stands on a flat platform. A master and servant are seated on its back with four attendants standing by the elephant's legs. The stoneware body is covered with a streaked brown glaze.

Not illustrated.

222.
Elephant
Thailand, date uncertain
Stoneware
H. 8.5 cm (3 3/8 in.)
72.728

This small, crudely modeled stoneware figure of a standing elephant is covered with a crackled celadon-type glaze, except for the legs.

Not illustrated.

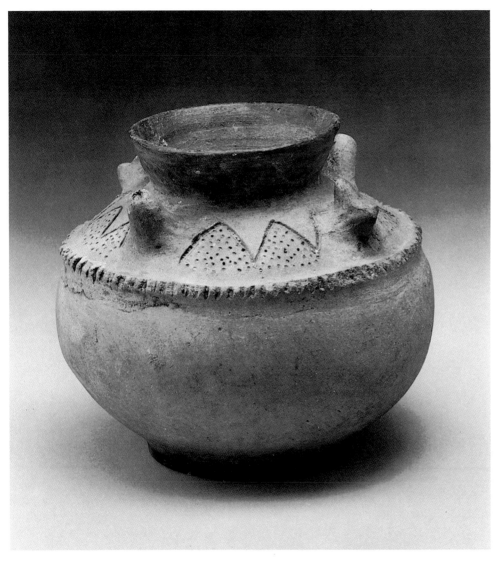

224. *Pouring Vessel*

223.
Animal Figure
Thailand, date uncertain
Stoneware
H. 6.7 cm (2 5/8 in.)
72.729

This small, crudely modeled figure of a standing animal—perhaps a dog or a bear—is coated with a streaked, brown glaze, except for the legs.

Not illustrated.

224.
Pouring Vessel
Philippines, Prehistoric Period,
1st-10th century A.D.
Earthenware
H. 18 cm (7 1/8 in.)
72.557

This reddish buff earthenware vessel has a rounded body and a low foot-rim. It has a sloping shoulder with a notched flange and a short, flaring neck. On the shoulder are two spouts alternating with two lugs; between them is a row of incised, open triangles filled in with stippled dots. (For a related vesssel, see Tenazas 1968, pl. 44.)

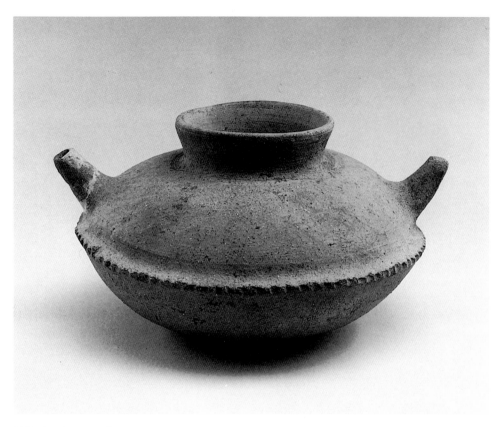

225. *Pouring Vessel*

225.
Pouring Vessel
Philippines, Prehistoric Period,
1st-10th century A.D.
Earthenware
H. 11.1 cm (4 3/8 in.)
72.561

This reddish buff earthenware vessel has a flattened spherical shape with a notched flange around the middle and a short neck. On the shoulder are a spout and a lug with an incised band in a crosshatch pattern. (For similar vessels, see Tenazas 1968, pl. 40.)

226. *Cooking Pot*

226.
Cooking Pot
Philippines, Prehistoric Period,
1st-10th century A.D.
Earthenware
H. 10.8 cm (4 1/4 in.)
Found in Batangas Province, Philippines
72.560

This reddish buff earthenware cooking pot
has a rounded base, an everted mouth-
rim, and carinated sides. The upper portion
of the sides shows an incised decoration
consisting of a band of indistinct linear de-
signs between borders of stippled dots.

227.
Cooking Pot
Philippines, Prehistoric Period,
1st-10th century A.D.
Earthenware
H. 11.1 cm (4 3/8 in.)
Found in Batangas Province, Philippines
72.558

This cooking pot of reddish buff earthen-
ware has rounded sides and base and a
flattened mouth-rim. It is decorated below
the rim with a band of combed vertical
lines above a border of stippled dots. The
main body has been burnished to a
high gloss.

Not illustrated.

228.
Cooking Pot
Philippines, Prehistoric Period,
1st-10th century A.D.
Earthenware
H. 12.8 cm (5 in.)
72.559

This globular cooking pot of reddish buff earthenware has a rounded base and an everted mouth-rim. It is decorated with a border of incised parallel lines below the rim.

Not illustrated.

229.
Jar
Philippines, Prehistoric Period,
1st-10th century A.D.
Earthenware
H. 16.5 cm (6 1/2 in.)
72.727

This globular reddish buff earthenware jar with a wide neck and an everted rim has a spreading foot-rim with two small holes opposite each other on the sides. The surface has vertical striations that were probably caused by a polishing material.

Not illustrated.

230.
Jar
South China or Indochina,
perhaps 13th-14th century
Stoneware
H. 6 cm (2 in.)
72.581

This squat gray stoneware jar with narrow neck and flat base is covered on the upper half with a grayish brown glaze.

Not illustrated.

231.
Jar
South China or Indochina,
perhaps 13th-14th century
Stoneware
H. 4.3 cm (1 7/8 in.)
72.563

This squat gray stoneware jar is similar to no. 230.

Not illustrated.

232.
Jar
Obscure origin and date
Stoneware
H. 6.2 cm (2 5/8 in.)
72.562

This crudely made, cylindrical jar with a wide mouth and a flat base has a dark gray stoneware body covered with a speckled gray glaze. (For related vessels, see Locsin 1967, pls. 30, 93, and 94.)

Not illustrated.

233.
Jar
Obscure origin and date
Earthenware
H. 7.6 cm (3 in.)
72.564

This crudely made, cylindrical jar has a wide mouth and a flat base. The creamy white earthenware body is covered with a streaked, green lead glaze. (For related vessels, see Locsin 1967, pl. 24.)

Not illustrated.

234.
Jar
South China or Indochina,
perhaps 13th-14th century
Stoneware
H. 8.5 cm (3 3/8 in.)
72.565

This cylindrical jar has a low, flaring
neck, four horizontal loop handles on the
shoulder, and a flat base. The gray
stoneware body is covered on the shoulder
with a thin, brown glaze.

Not illustrated.

235.
Jar
South China or Indochina, date uncertain
Stoneware
H. 12.4 cm (4 7/8 in.)
72.585

This crudely made, misshapen, ovoid jar
has a narrow neck, two horizontal
loop handles on the shoulder, and a flat
base. The coarse gray stoneware body is
covered with a streaked, brown glaze that
stops irregularly above the base.

Not illustrated.

References Cited

Aga-Oglu 1955
Aga-Oglu, Kamer. "The So-Called 'Swatow' Wares: Types and Problems of Provenance." *Far Eastern Ceramic Bulletin* 7/2 (June 1955): 1-34, pls. 1-24.

Aga-Oglu 1963
Aga-Oglu, Kamer. "Ming Porcelain from Sites in the Philippines." *Archives of the Chinese Art Society of America* 17 (1963): 7-19.

Aga-Oglu 1972
Aga-Oglu, Kamer. *The Williams Collection of Far Eastern Ceramics: Chinese, Siamese, and Annamese Ceramic Wares Selected from the Collection of Justice and Mrs. G. Mennen Williams in The University of Michigan Museum of Anthropology.* Exh. cat. Ann Arbor: University of Michigan Museum of Anthropology, 1972.

Aga-Oglu 1975
Aga-Oglu, Kamer. *The Williams Collection of Far Eastern Ceramics: Tonnancour Section.* Ann Arbor: University of Michigan Museum of Anthropology, 1975.

Bahrami 1949-50
Bahrami, Medhi. "Chinese Porcelains from Ardebil in the Teheran Museum." *Oriental Ceramic Society Transactions* 25 (1949-50): 13-19.

Cheng 1972
Cheng, Te-k'un. "The Study of Ceramic Wares in Southeast Asia." *Journal of the Institute of Chinese Studies* (Chinese University of Hong Kong) 5/2 (December 1972): 1-40, pls. 1-28.

d'Argencé 1967
d'Argencé, René-Yvon Lefebvre. *Chinese Ceramics in the Avery Brundage Collection.* San Francisco: M. H. de Young Memorial Museum, 1967.

de Flines 1975
de Flines, E. W. Van Orsoy. *Guide to the Ceramic Collection (Foreign Ceramics).* Museum Pusat Jakarta, 1975.

Frasché 1976
Frasché, Dean F. *Southeast Asian Ceramics: Ninth Through Seventeenth Centuries.* Exh. cat. New York: The Asia Society, 1976.

Garner 1954
Garner, Sir Harry. *Oriental Blue and White.* London: Faber and Faber, 1954.

Hobson 1933-34
Hobson, R. L. "Chinese Porcelain at Constantinople." *Oriental Ceramic Society Transactions* 11 (1933-34).

Jenyns 1953
Jenyns, Soame. *Ming Pottery and Porcelain.* London: Faber and Faber, 1953.

Joseph 1971
Joseph, Adrian M. *Ming Porcelains: Their Origins and Development.* London: Bibelot, 1971.

Lee 1949
Lee, Jean Gordon. "*Ming Blue-and-White* [Catalogue of an exhibition held at the Philadelphia Museum of Art, October 29-December 4, 1979]." *Philadelphia Museum Bulletin* 44/223 (Autumn 1949): 3-72.

Lee/Ho 1968
Lee, Sherman E., and Wai-kam Ho. *Chinese Art Under the Mongols: The Yuan Dynasty (1279-1368).* Exh. cat. The Cleveland Museum of Art, 1968.

Lion-Goldschmidt 1978
Lion-Goldschmidt, Daisy. *Ming Porcelain,* trans. Katherine Watson. New York: Rizzoli, 1978.

Locsin 1967
Locsin, Leandro and Cecilia. *Oriental Ceramics Discovered in the Philippines.* Rutland, Vt.: C.E. Tuttle Co., 1967.

Ottema 1946
Ottema, Nanne. *Chineesche ceramiek handboek geschreven naar aanleiding van de verzamelingen in het Museum Het Princessehof te Leeuwarden.* 2nd ed. Amsterdam: J. H. de Bussy, 1946.

Palmgren/Steger/Sundius 1963
Palmgren, Nils, Walter Steger, and Nils Sundius. *Sung Sherds.* Stockholm: Almquist & Wiksell, 1963.

Pope 1952
Pope, John A. *Fourteenth-Century Blue-and-White: A Group of Chinese Porcelains in the Topkapu Sarayi Müzesi, Istanbul,* Freer Gallery of Art Occasional Papers, vol. II, no. 1. Washington, D.C.: Smithsonian Institution, 1952.

Pope 1956
Pope, John A. *Chinese Porcelains from the Ardebil Shrine.* Washington, D.C.: Freer Gallery of Art, Smithsonian Institution, 1956.

Spinks 1965
Spinks, Charles N. *The Ceramic Wares of Siam.* Bangkok: Siam Society, 1965.

Sullivan 1957
Sullivan, Michael. "Kendi." *Archives of the Chinese Art Society of America* 11 (1957): 40-58.

Tenazas 1968
Tenazas, Rosa, C.P. *A Report on the Archaeology of the Locsin—University of San Carlos Excavations in Pila, Laguna.* Manila, 1968.

Tokyo 1965
Tokyo National Museum. *Illustrated Catalogues of the Tokyo National Museum: Chinese Ceramics.* 1965.

Valenstein 1970
Valenstein, Suzanne G. *Ming Porcelains: A Retrospective. Catalogue of a Loan Exhibition, China Institute in America.* Exh. cat. New York: China Institute in America, 1970.

Wirgin 1964
Wirgin, Jan. *Ming Blue-and-White from Swedish Collections. Museum of Far Eastern Antiquities Exhibition Catalogue No. 1.* Stockholm: Museum of Far Eastern Antiquities, 1964.

Zimmermann 1930
Zimmermann, Ernst. *Altchinesische Porzellane im Alten Serai,* vol. II of *Meisterwerke der Türkischen Müseen zu Konstantinopel.* Berlin and Leipzig: W. de Gruyter and Company, 1930.

Brown, Roxanna M. *The Ceramics of South-East Asia: Their Dating and Identification.* Kuala Lumpur/New York, Oxford University Press, 1977.

———, and Adrian Joseph, eds. *South-East Asian and Chinese Trade Pottery.* Exh. cat. The Oriental Ceramic Society of Hong Kong, 1979.

Columbus Museum of Art. *Shadow of the Dragon: Chinese Domestic and Trade Ceramics.* Exh. cat. 1982.

Harrisson, Barbara. *Swatow In Het Princessehof.* Leeuwarden: Gemeentelijk Museum het Princessehof, 1979.

Joseph, Adrian M. *Chinese and Annamese Ceramics Found in the Philippines and Indonesia.* London: Hugh Moss, 1973.

Wiesner, Ulrich. *Chinesische Keramik auf den Philippinen: Die Sammlung Eric E. Geiling.* Cologne: Museum für Ostasiatische Kunst, n.d.

Spelling Systems for Chinese

Wade-Giles	Pinyin	Wade-Giles	Pinyin
Ch'an Buddhist	Chan	Sung	Song
ch'ang	chang	Te-hua	Dehua
Chekiang	Zhejiang	T'ien-mu	Tianmu
Ch'eng-hua	Chenghua	Wan-li	Wanli
chia	jia	ying-ch'ing	yingqing
Chia-ching	Jiajing	Yüan	Yuan
Chien	Jian		
ch'i	qi		
Ch'ing	Qing		
ch'ing-pai	qingbai		
Ch'ing-te chen	Jingdezhen		
ch'ing tz'u	qing ci		
Fukien	Fujian		
Foochow	Fuzhou		
Hsüan-tê	Xuande		
Hsüan Tê Nien Tsao	Xuande nianhao		
Kiangsi	Jiangxi		
kuan	guan		
Kuangtung	Guangdong		
kuei	gui		
Lung-ch'üan	Longquan		
mei-p'ing	meiping		
shou	shou		
Shou-hsing	Shouxing		
shu-fu	shufu		

72.661 (W.72), *Tea Bowl* (China),
no. 4, p. 15

72.662 (W.786), *Tea Bowl* (China),
no. 3, p. 15

72.663 (W.179), *Dish* (China),
no. 31, p. 31

72.664 (W.236), *Dish* (China),
no. 39, p. 34

72.665 (W.451), *Dish* (China),
no. 24, p. 28·

72.666 (W.686), *Dish* (China),
no. 64, p. 47

72.667 (W.320), *Dish* (China),
no. 26, p. 30

72.668 (W.656), *Dish* (China),
no. 27, p. 30

72.669 (W.289), *Jar* (China), no. 56, p. 42

72.670 (W.370), *Jar* (China), no. 57, p. 42

72.671 (W.390), *Tea Pot* (China),
no. 46, p. 36

72.672 (W.413), *Tea Pot with Cover*
(China), no. 45, p. 36

72.673 (W.306), *Kendi Vessel* (China),
no. 9, pp. 18-19

72.674 (W.646), *Wine* or *Sauce Pot*
(China), no. 93, p. 64

72.675 (W.602), *Kendi Vessel* (China),
no. 183, p. 116

72.676 (W.704), *Jar* (China), no. 10, p. 19

72.677 (W.705), *Jar* (China), no. 11, p. 19

72.678 (W.735), *Dish* (China),
no. 37, p. 32

72.679 (W.771), *Dish* (China),
no. 60, p. 44

72.680 (W.401), *Tea Pot* (China),
no. 186, p. 117

72.681 (W.581), *Dish* (China),
no. 71, p. 53

72.682 (W.607), *Dish* (China),
no. 76, p. 54

72.683 (W.235), *Jar* (China), no. 52, p. 40

72.684 (W.48), *Jar* (China), no. 132, p. 81

72.685 (W.308), *Jar* (China), no. 125, p. 78

72.686 (W.474), *Jar* (China), no. 131, p. 81

72.687 (W.478), *Jar* (China), no. 124, p. 77

72.688 (W.11), *Bell* (China),
no. 13, p. 20

72.689 (W.164), *Dish* (China),
no. 38, p. 33

72.690 (W.524), *Dish* (China),
no. 68, p. 49

72.691 (W.654), *Dish* (China),
no. 61, p. 45

72.692 (W.717), *Dish* (China),
no. 59, p. 43

72.693 (W.546), *Dish* (China),
no. 67, p. 49

72.694 (W.573), *Dish* (China),
no. 175, p. 113

72.695 (W.676), *Jar* (China),
no. 174, p. 113

72.696 (W.739), *Dish* (China),
no. 35, p. 32

72.697 (W.137), *Jar with Cover* (China),
no. 12, p. 20

72.698 (W.140), *Box with Cover* (China),
no. 149, p. 94

72.699 (W.434), *Dish* (China),
no. 134, p. 83

72.700 (W.742), *Dish* (China),
no. 135, p. 84

72.701 (W.25), *Jar* (China),
no. 141, pp. 88-89

72.702 (W.29), *Wine Vessel* (China),
no. 151, p. 96

72.703 (W.265), *Dish* (China),
no. 157, p. 102

72.704 (W.608), *Dish* (China),
no. 137, p. 84

72.705 (W.27), *Dish* (China),
no. 163, p. 107

72.706 (W.31), *Dish* (China),
no. 162, p. 106

72.707 (W.672), *Dish* (China),
no. 158, p. 103

72.708 (W.181), *Dish* (China),
no. 136, p. 84

72.709 (W.368), *Dish* (China),
no. 133, p. 82

72.710 (W.397), *Bowl* (China),
no. 154, p. 99

72.711 (W.485), *Bowl* (China),
no. 155, p. 99

72.712 (W.623), *Kendi Vessel* (China),
no. 139, p. 86

72.713 (W.664), *Dish* (China),
no. 164, p. 107

Designed by Colophon.
Typeset in Poppl-Pontifex
by Marino & Marino Typographers.
One thousand copies printed
on Vintage Gloss Enamel
by Young & Klein, Inc.
Photography by Dirk Bakker
and Thomas Kramer.